IMAGES
of America

THE VARSITY

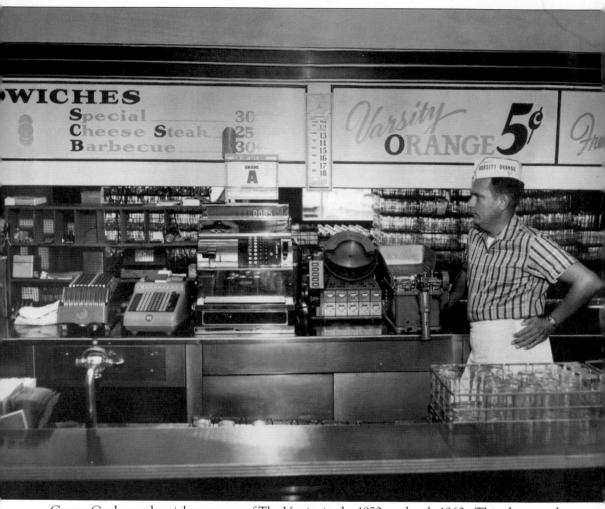

George Cook was the night manager of The Varsity in the 1950s and early 1960s. This photograph from August 1956 shows Cook behind the counter between rushes. The cash register to his right was one of three along the 145-foot counter. To expedite orders, cash from transactions was placed in mayonnaise jars kept below the counter. Racks of Varsity glasses can be seen on the counter and in the background. (The Varsity.)

ON THE COVER: The cover photograph was taken in 1955 at the counter of The Varsity. Pictured here are, from left to right, Jim Walters, Darby ?, Joe Barbaree, night manager George Cook, curb manager Dwight Gant, and unidentified. (The Varsity.)

IMAGES
of America

THE VARSITY

Janice McDonald

ARCADIA
PUBLISHING

Published by Arcadia Publishing
Charleston, South Carolina

Printed in the United States of America

Library of Congress Control Number: 2011925639

For all general information, please contact Arcadia Publishing:
Telephone 843-853-2070
Fax 843-853-0044
E-mail sales@arcadiapublishing.com
For customer service and orders:
Toll-Free 1-888-313-2665

Visit us on the Internet at www.arcadiapublishing.com

This book is for my hot dog–loving mother,
Dorothy McDonald, and my onion ring–addicted sisters,
Paula McDonald Miles and Anna McDonald Boyce.

CONTENTS

Acknowledgments 6

Introduction 7

1. The Varsity 9

2. The World's Largest Drive-In 35

3. Mr. Varsity 63

4. What'll Ya Have? 79

5. The Varsity Forever 97

ACKNOWLEDGMENTS

Words cannot express my gratitude to The Varsity family for their shared memories, help, and excitement about this book. Gordon Muir took that first phone call about the idea and then endured so many calls and e-mails afterwards, never faltering in his help. Nancy Gordy Simms's memories and insight really helped give a sense of her parents and just how important The Varsity is to so many. To Terry Brookshire and Terri Howard, thanks so much for always welcoming my knock on the door and for all of the help with names in photographs. Frank Jones—your memory is amazing! Diane Alderman, of the Gordy Foundation, was simply invaluable in helping me sort through the archives and adding to the anecdotes. Chris McLaughlin has spent so much time studying the history of The Varsity and Atlanta and was able to give important insight and context.

The book would not be complete without the help of Erby Walker's daughter Anissa Walker Thompson (AWT), who opened up her family albums to me and is so very proud of her father. During the never-ending search for photographs, I received great help from Ellen Johnson of Georgia State University Library, Special Collections and Archives (GSUL); Betsy Rix, of Atlanta History Center (AHC); Christine de Catanzaro, of Georgia Tech (Tech); Joel Langford, of Reinhardt University; Ted Ryan and Justine Fletcher, of The Coca-Cola Company (CC); and Susan Reilly, of Decatur High School. Cheering me along and offering up suggestions were my family (thanks Ryan Miles!) and friends—particularly Barbara Lynn Howell and Karen Rosen, who helped make calls and talked to people on my behalf. I also want to thank Jim Walters, who is pictured on the cover of this book and who helped identify others in the photograph and shared wonderful, fun stories of his time at The Varsity.

So many Varsity fans posted memories and photographs through their website, and I just wish there was room to include them all. Finally, I want to thank my editor, Brinkley Taliaferro, who leapt at being involved in this book and whose support was unwavering.

Unless otherwise noted, all photographs are courtesy of The Varsity.

INTRODUCTION

Just the sound of the words, "What'll ya have, what'll ya have?" can instantly transport a legion of fast-food fans to the legendary institution simply called The Varsity. Located in downtown Atlanta, The Varsity is the undisputed World's Largest Drive-In. The "What'll ya have?" mantra from order-takers greets countless customers daily upon the moment they walk through the doors of The Varsity. Once inside the fast-paced fast-food haven, the faithful know to "have your money in your hand and your order on your mind."

Varsity founder Frank Gordy had never been in a restaurant kitchen before he began his hot dog empire in a small shack near his uncle's garage at the corner of Luckie Street and North Avenue. Gordy had briefly attended the Georgia Institute of Technology (Georgia Tech) and was frustrated because food service was so expensive in the dining halls. By opening his hot dog stand, the Yellow Jacket, in 1926, he sought to offer students good, affordable food prepared swiftly. The response was almost overwhelming.

Gordy's 12-by-7-foot structure was only big enough for a grill, a kettle to boil his hot dogs, and a place to chill his Coca-Colas. The Yellow Jacket quickly outgrew the small space, and with $1,860 in profits, Gordy leased a house just up North Avenue, near the corner of Spring Street, and constructed a small brick building in its yard. The new restaurant was named The Varsity because Gordy was already formulating plans to expand his concept to other universities. At the new Varsity, customers could either pick up their food at the window or come in and sit at the six-seat counter.

At a time when most people did not eat out and were used to home cooking, hot dogs, hamburgers, and onion rings were considered an exotic treat. The fact that nothing on the menu cost more than 10¢ brought in customers by the droves. On its first day, The Varsity posted $47.30 in sales, an almost unheard-of sum. Within a few years of opening, The Varsity had cemented its place in fast-food history.

The location grew, then grew, and then grew again to include a massive parking lot spreading over two acres of land. To speed up service, Gordy recruited servers who would take orders after hopping on a car's running boards as it pulled into the parking lot. The term "carhop" became a permanent fixture in the American vernacular, and Gordy ultimately had more than 130 carhops running through The Varsity lots, orders in hand. Working only for tips, many of them made enough to put themselves through college or buy cars and houses.

A stickler for quality, Gordy developed all of the recipes himself, including the recipe used for The Varsity hot dogs. Chili dogs were his daily meal, and he sampled all of the food regularly to make sure it remained consistent—Gordy could immediately taste any variation in his recipes.

Gordy also insisted upon freshness. Delivery trucks of all kinds made their stops at The Varsity throughout the day to adhere to Gordy's motto: "No food is more than 12 hours old." The deliveries occurred so often that for some drivers, The Varsity was their only stop. Suppliers knew not to cut corners on the quality levels of products they brought to The Varsity.

While Gordy admitted he might not have been a great student at Georgia Tech, his engineering design talents were undisputed when it came to developing machines that would help speed along the kitchen's ability to cook and serve. To maintain order and efficiency, he structured the kitchen much like a factory assembly line, complete with conveyor belts to serve hot foods. Each food item had its own distinct way of being assembled and most worked in concert with one another. The orchestration allowed The Varsity to serve thousands of people daily without diminishing the quality of the food. Other businesses marveled at and studied his practices.

The Varsity became the place to be for students wanting to socialize, families seeking an inexpensive meal, and businessmen in a hurry. Gordy was a constant presence. He and his staff treated their customers like family, and the customers returned the favor. Although an Athens Varsity opened its doors just four years after the Atlanta location, Gordy abandoned plans to build a Varsity on every major university campus. He said he realized that he would not be able to personally oversee them all and wanted to concentrate on growing what he already had.

Movie stars still go out of their way to get a taste of this Atlanta institution. During the Atlanta premiere of the movie *Gone with the Wind*, Rhett Butler himself—Clark Gable—came to The Varsity. His waiter? The flamboyant and legendary John Wesley Raiford, known as Flossie Mae, who was noted for singing the entire menu to his customers. Over the decades, The Varsity has played host to presidents, including Jimmy Carter, George H.W. Bush, and Bill Clinton. It is hard to say just how many sports heroes and celebrities have dined here, but the late comedian Nipsey Russell once worked at The Varsity as a carhop. On any given day, one can spot visitors from a host of foreign countries enjoying the food.

The Varsity has set records for the vast amounts of food sold daily. Having sold Coca-Cola products since Gordy's days in his small shack, The Varsity claims the honor of being the world's largest single restaurant consumer of Coke products. On a daily basis, the staff serves up two miles of hot dogs, a ton of fresh cut onion rings, 2,500 pounds of potatoes, 5,000 fried pies, and 300 gallons of chili. And, remember, all of the food is made from scratch daily.

The first day The Varsity ever closed its doors for business was the day of Frank Gordy's funeral in 1983. His daughter Nancy Gordy Simms stepped in to run The Varsity, followed by her own son Gordon Muir. The Varsity is still very much a family affair, and the employees and many customers count themselves as being part of that family.

The Varsity is not just a restaurant, it is a tradition. For years, the Georgia Legislature simply could not drop the gavel to adjourn their year without first dining on food from The Varsity. And if you pay attention, you will likely see the same faces weekly and sometimes daily. They are The Varsity regulars.

In some cases, they are multigenerational fans carrying out a love for The Varsity that began when the restaurant started and who are raising new generations of Varsity lovers. In other cases, it is those who have heeded the "What'll ya have?" call and were instantly hooked.

One

THE VARSITY

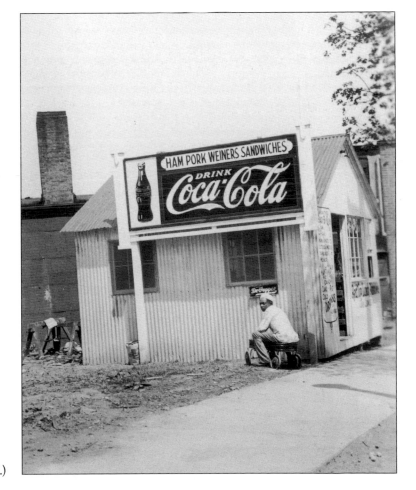

It was barely a shack and certainly not a restaurant, but Frank Gordy felt this 12-foot-wide wooden structure adjacent to his uncle Bob Ingram's gas station showed promise. Located at North Avenue and Luckie Street, across from the Georgia Institute of Technology, the building was big enough for a grill, a pot for boiling hot dogs, and an icebox full of Coca-Cola. Gordy called it "The Yellow Jacket." (AHC.)

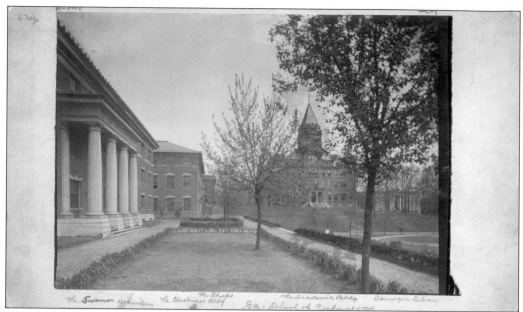

The Yellow Jacket was located just a block from Georgia Tech's Janie Swann Dormitory. As a former Georgia Tech student, Gordy complained that he would have to pay 50¢ to 75¢ at the dining hall for a meal that offered him little choice. He wanted to offer Tech students an affordable option, and the proximity to Swann was key. The Yellow Jacket's walk-up window was a unique idea. (Tech.)

The corner near the Yellow Jacket was a drop-off point for the trolley that ran to downtown Atlanta. Not only was it the perfect spot for hungry students to walk over and grab a quick bite, anyone riding the trolley could see it. Location, menu, and price proved a winning combination that would serve Gordy well for decades. (AHC.)

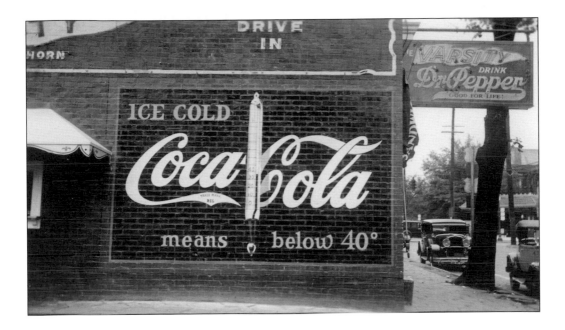

Within a year of opening, it was obvious that the Yellow Jacket's success could not be contained. Gordy took $1,860 in profits and leased a house up the street, at 55 North Avenue, and constructed a small brick building in its front yard. Gordy felt he could take advantage of the foot traffic from the trolley stop at Peachtree Street and North Avenue. The 14-by-35-foot building had a six-stool counter inside and a walk-up window. With his eyes on the future, Gordy named the new restaurant "The Varsity," theorizing that he would eventually use his food formula on other college campuses. He continued operating the Yellow Jacket for a time, but The Varsity quickly proved to be the place to concentrate his efforts. The day The Varsity opened its doors, it served about 300 customers. (Both, AHC.)

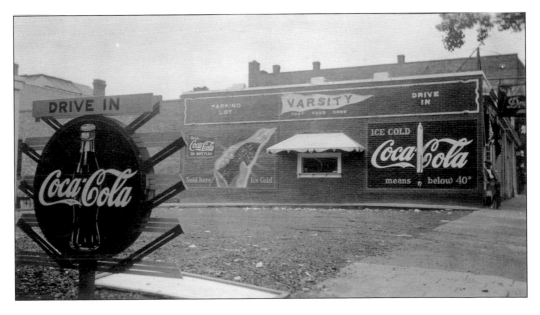

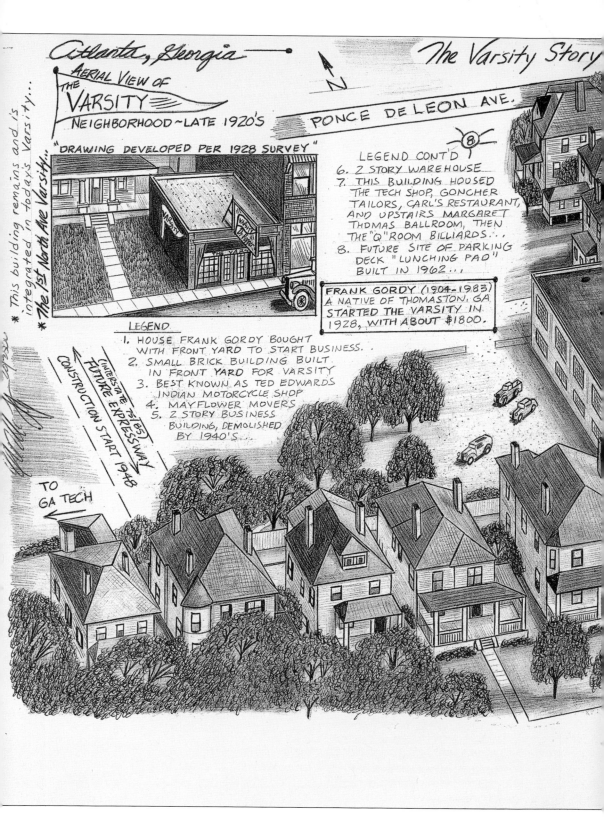

Atlanta, Georgia

AERIAL VIEW OF
THE
VARSITY
NEIGHBORHOOD ~ LATE 1920'S

N

PONCE DE LEON AVE.

"DRAWING DEVELOPED PER 1928 SURVEY"

* This building remains and is integrated in today's Varsity...
* The 1st North Ave Varsity...

LEGEND CONT'D
6. 2 STORY WAREHOUSE
7. THIS BUILDING HOUSED THE TECH SHOP, GONCHER TAILORS, CARL'S RESTAURANT, AND UPSTAIRS MARGARET THOMAS BALLROOM, THEN THE "Q" ROOM BILLIARDS...
8. FUTURE SITE OF PARKING DECK "LUNCHING PAD" BUILT IN 1962...

FRANK GORDY (1904-1983) A NATIVE OF THOMASTON, GA STARTED THE VARSITY IN 1928, WITH ABOUT $1800.

LEGEND
1. HOUSE FRANK GORDY BOUGHT WITH FRONT YARD TO START BUSINESS.
2. SMALL BRICK BUILDING BUILT IN FRONT YARD FOR VARSITY
3. BEST KNOWN AS TED EDWARDS INDIAN MOTORCYCLE SHOP
4. MAYFLOWER MOVERS
5. 2 STORY BUSINESS BUILDING, DEMOLISHED BY 1940'S...

INTERSTATE 75 (85) FUTURE EXPRESSWAY CONSTRUCTION START 1948

TO GA TECH

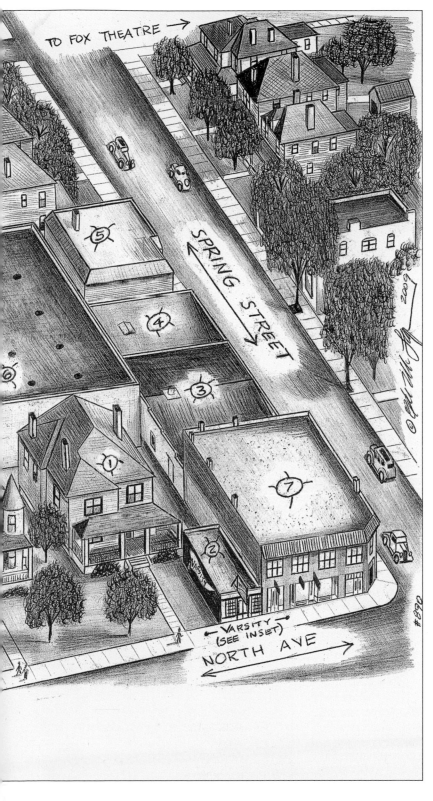

Artist Chris McLaughlin is noted for his meticulous depictions of Atlanta landmarks. He spent hours researching historic details to create this drawing, which shows the North Avenue neighborhood at the time The Varsity first opened. The Varsity is the small building in the lower right corner, labeled "2." The inset at top left shows a magnified view. Frank Gordy first leased the house next to The Varsity, so he would have the property to build his new restaurant. It and the second house eventually were torn down to make space for parking lots. Interstates 75 and 85 now run through the area where the last two houses on the left are depicted. The original building is the present-day location of the third television room of The Varsity. (Chris McLaughlin.)

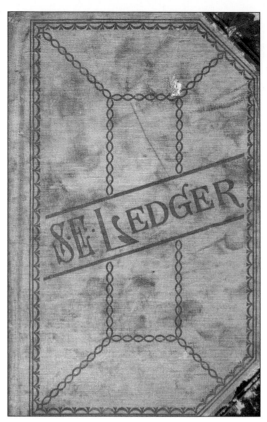

This ledger of accounts from the first four months of The Varsity's operation is a testament to the immediate success of the restaurant. On the first day of business, the restaurant made $47.30. Keep in mind that at that time, hot dogs were just 5¢ each. The most expensive items on the menu cost only 10¢. Feasting on an exotic fare of hot dogs and hamburgers for such an inexpensive price was a temptation few could pass up. This page of entries is from August 1928, and while the decimal is missing from most of the figures, the totals are still impressive for those days. Even on October 28, 1929, the day of the stock market crash that began the Great Depression, The Varsity posted $68.30 in receipts. The single entry (S.E.) ledger was Gordy's accounting system for decades.

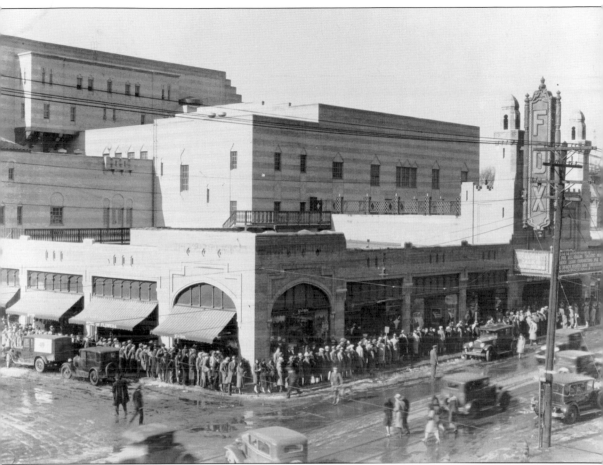

The Fox Theatre opened its doors on Christmas Day, 1929, just three blocks up the street from The Varsity. Located at the corner of Peachtree Street and Ponce de Leon Avenue, the elaborate building originally served as the Yaarab Temple Shrine Mosque before being sold to movie mogul William Fox for $225,000 and converted to a movie theater. A full house turned out to take part in the opening day festivities, paying 60¢ each for a ticket (20¢ for children). The celebration included the showing of the feature film *Salute* and performances by the Fox Grand Orchestra. After the last show, 2,000 people made the trek down to the tiny Varsity to eat, a pilgrimage that has been repeated countless times by hundreds of thousands of people. (Fox Theatre.)

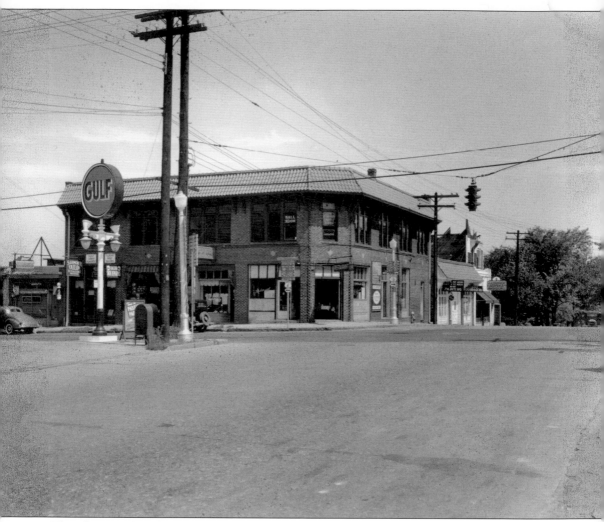

This photograph, taken from Spring Street looking north to North Avenue, shows The Varsity's neighbors in the early 1930s. The business on the corner was a restaurant called Carl's. To its right, along Spring Street, was a garage and then Mayflower Movers. The corner of North Avenue and Spring Street was a major thoroughfare. Notice the Highway 41 destination signs, which pointed travelers towards Marietta, Cartersville, Dahlonega and Austell, as well as cities as far away as Blue Ridge, North Carolina; Chattanooga, Tennessee; and Birmingham, Alabama. Atlanta was an important crossroads for travelers by both car and air. In 1929, the year after The Varsity opened, the City of Atlanta bought Candler Field airport and operated daily flights between Atlanta and Birmingham. (AHC.)

Frank Gordy decided to expand his business by diversifying. He added on to the original building, opening a barbershop in November 1928. Georgia Tech's *Technique* newspaper announced that M.H. Howard would be the manager. By 1930, Gordy had expanded again, moving the barbershop over and putting a bowling alley in the old shop location. The six-lane alley featured duckpin bowling, utilizing a ball with a five-inch diameter.

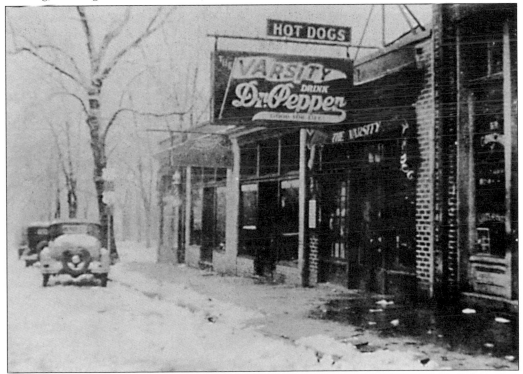

A rare Atlanta snowfall in 1930 was not enough to close The Varsity's doors. Gordy believed in keeping his business open through all conditions and on holidays. He even advertised, "Come Have Christmas Dinner at The Varsity." While Gordy used profits from The Varsity to help expand the business, he turned profits from the barbershop over to his wife, Evelyn, to assist in running the household.

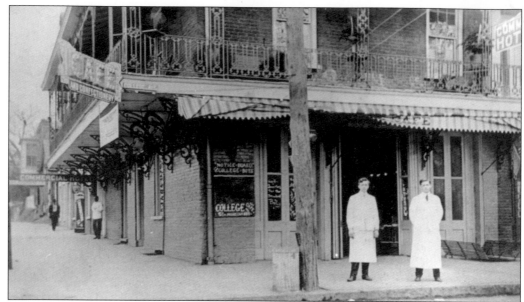

On March 11, 1932, Gordy opened his second Varsity restaurant at 101 College Avenue in Athens, Georgia, directly across the street from the Arch at the University of Georgia. The image above shows two men in front of a café that operated in the location at the turn of the 20th century. At the time Gordy purchased the building, it was occupied by a soda fountain and sandwich bar called "Gus's." Gordy was committed to bringing affordable food to students and had a vision that he could repeat his successful Varsity formula by opening restaurants on major college campuses throughout the country. That vision was behind naming the restaurant "The Varsity" in the first place, since he felt the collegiate name would appeal to student customers.

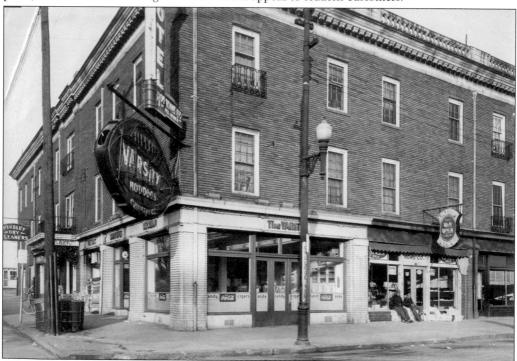

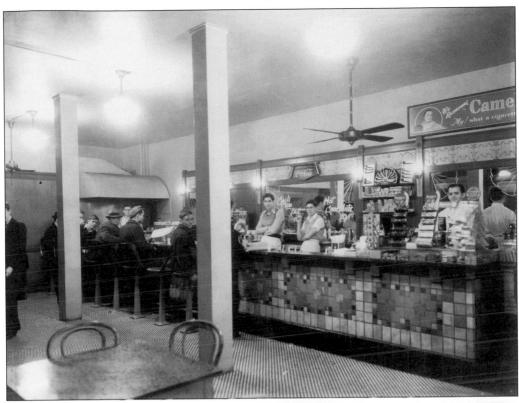

Epp Suddath (far right) began working with Gordy as a teenager, when the Yellow Jacket opened. When it came time to open the Athens restaurant, Gordy knew he could trust Suddath to maintain the same strict quality he demanded from the Atlanta location. Suddath recruited employee Joe Coley to go with him. Once there, he hired Bill Moore and Guy Biggs, both of whom had worked at Gus's.

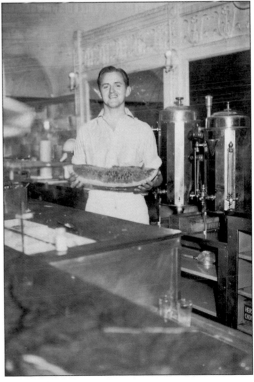

Suddath agreed to work in Athens on a six-month trial basis, but he met his wife, Juanita, while working in Athens and stayed there for almost 40 years. Opening The Varsity–Athens made Gordy realize that it would be impossible to sustain his standards in multiple locations, and he abandoned plans to open Varsity restaurants throughout the United States.

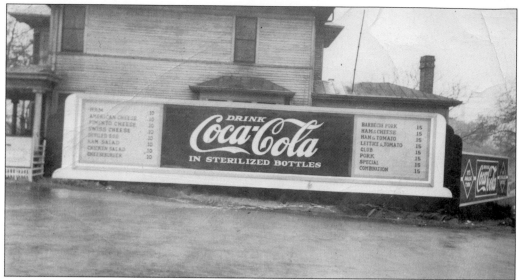

The Varsity's first parking lot featured this massive menu. After impatient customers started pulling up and honking their horns for orders, Gordy recruited curb boys to handle requests. Because deliveries had to go past two storefronts, Gordy moved The Varsity down to the end building to be near the lot. On June 30, 1932, he paid $4,500 to buy all of the land on which The Varsity businesses sat.

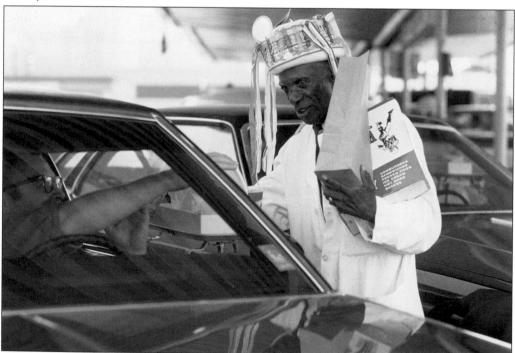

John Wesley Raiford began working at The Varsity in 1937, learning quickly that to earn good tips, a carhop had to stand out. His flamboyant mannerisms prompted a customer to call him "Flossie." Going one better, he started calling himself "Flossie Mae." Hat-wearing Grand Ole Opry star Minnie Pearl bestowed Flossie with a hat, and he soon started decorating them. Flossie also entertained his customers by singing the entire menu.

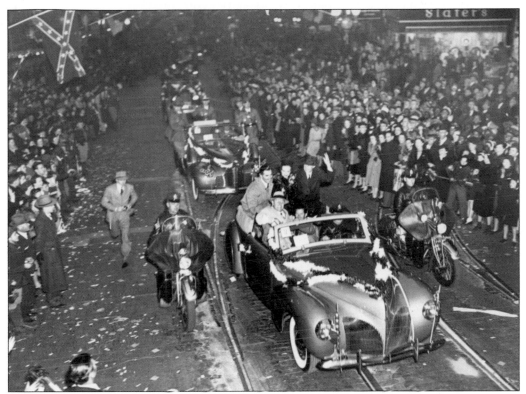

When *Gone with the Wind* premiered in Atlanta in 1939, Clark Gable paid a visit to The Varsity and it was Flossie Mae who served him. Flossie became a celebrity in his own right, appearing on television and having articles written about him. His elaborate hats suited all occasions and themes. Flossie worked at The Varsity for 56 years, retiring at the age of 86. (AHC.)

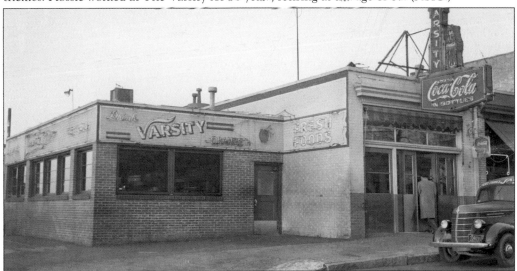

With The Varsity lot becoming so busy, Gordy moved his storefront, swapping locations with the barbershop on the end so the restaurant would be adjacent to where his customers drove in. The new address was 61 North Avenue, the same address used by The Varsity of today. Neon lights outlined the signs on its exterior so that it would stand out to customers at night.

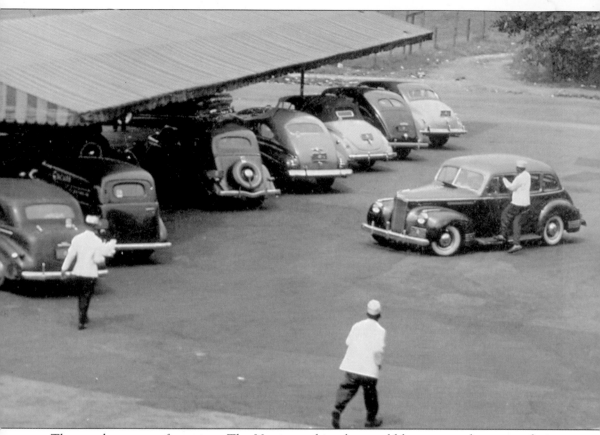

The steady stream of cars into The Varsity parking lot would have created mass confusion anywhere else, but an army of curb men made sure no car went untended. The curb boys quickly found they could expedite the process if they simply hopped on a car's running board as soon as it arrived, rode it as long as it took to get an order, and then hopped back off again to take the order inside. Thus, the term "carhop" was born. Carhops were unsalaried until the 1960s, working entirely for tips. But for Varsity curb men, tips alone generally exceeded most people's regular salaries. One carhop put himself through college on his tips, became a professor, and continued to work part-time at The Varsity.

It was common in the 1920s and 1930s for workers in diners to wear paper hats, and The Varsity was no different. Gordy's hats also advertised features of his menu. This original hat promoted the Varsity Orange drink on one side and sandwiches on the other. Wearing The Varsity paper hat is a tradition that continues to this day.

Carhops were each assigned a number to wear on their uniforms so customers could identify who was waiting on them. Each carhop's menu order forms were marked on the back with a coinciding number to keep orders from being confused. Two Varsity numbers have been retired over the years—No. 4, which was John "Flossie Mae" Raiford's, and No. 46, which belonged to Nipsey Russell.

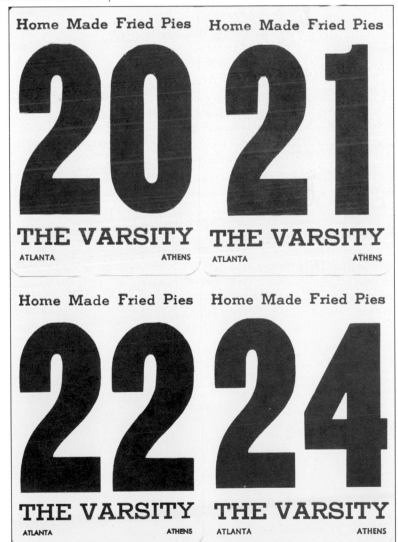

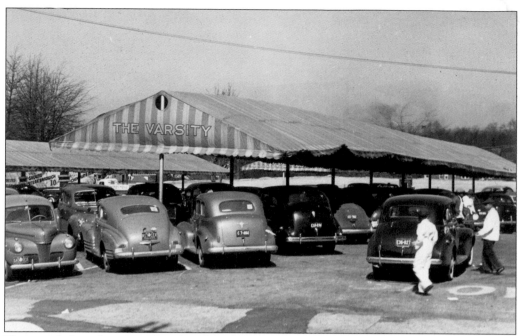

The crowded, cinder-covered parking lot of The Varsity shown here reflects just how popular the drive-in had become. The red and white awnings topping the parking places were added to give customers a picnicking feeling as they dined in their cars. It also helped protect the food trays from being rained on.

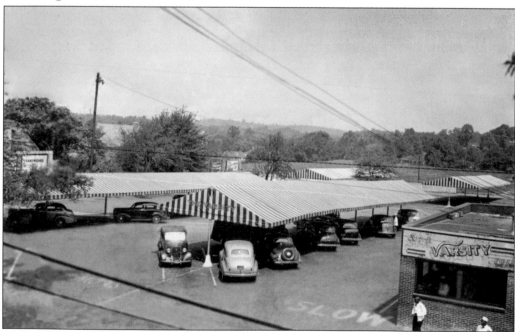

North Avenue got its name because it was the northern boundary of Atlanta, and at the time The Varsity was founded, it was still considered the edge of town. By 1938, however, Highway 41, between Atlanta and Marietta, had become Georgia's first four-lane highway. The trees in the distance are where Interstates 75 and 85 are now located.

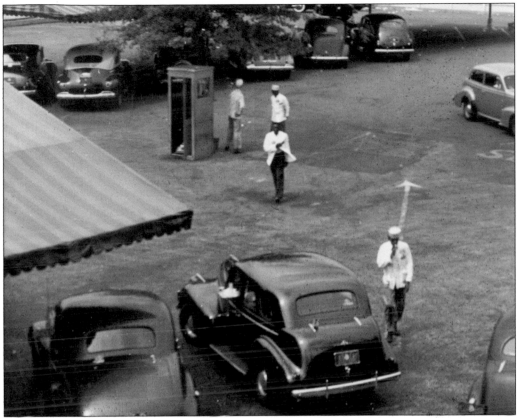

By the early 1940s, the Bell South Telephone and Telegraph Company was celebrating more than 60 years of business and The Varsity had a telephone booth in the middle of the parking lot for customers' convenience. Atlanta's population was just over 300,000 people, and less than a third of them had phones in their homes.

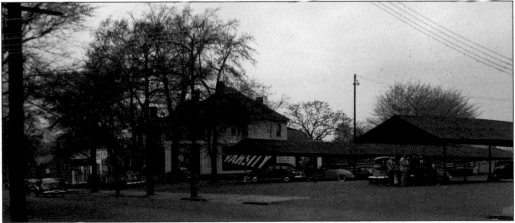

This 1948 photograph shows a group of businessmen in the North Avenue parking lot of The Varsity. While Gordy's plan was to cater to Georgia Tech students, it did not take long for word to spread that one could get good food fast at The Varsity. By 1950, just 30 percent of The Varsity's customers were students and 80 percent of the restaurant's business was outside service by carhops. (GSUL.)

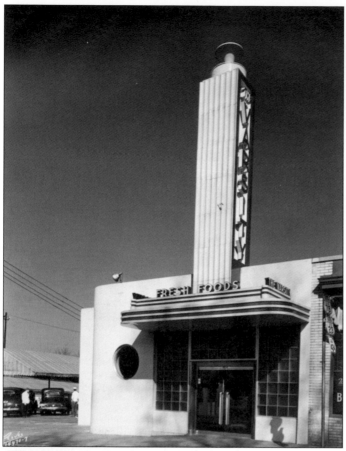

In the 1940s, The Varsity underwent another major makeover. To give the old brick structure a more modern look, white stucco siding was added that created a curve where two of the early brick buildings were joined. The concept, by architect Jules Grey, was designed to make the building look as streamlined as the cars now pulling up for service. The original buildings remain beneath the present-day Varsity's exterior.

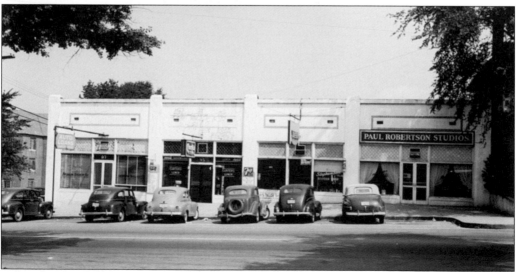

This little shopping plaza stood west of The Varsity at North Avenue and Williams Street at what is now the southbound exit ramp for Interstate 75/85. The mall included American Discount Auto Loans, Cook's Lunch Counter, a tailor shop, Stephenson's Barbershop, and Paul Robertson Photo Studios. The buildings at left are Georgia Tech dormitories, which are still standing. (GSUL.)

Ted Edwards Indian Motorcycles was located on Spring Street, right next to The Varsity. At one point, there was a back entrance that workers from Ted's could go through to enter The Varsity. An internationally recognized motorcycle rider in his own right, Edwards operated his shop from 1940 to 1950, when the Indian parent company closed shop. He later became a race promoter at Lakewood Speedway. (GSUL.)

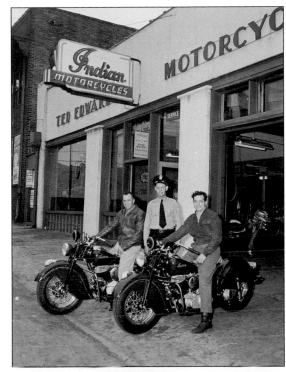

The shopping center is on the bottom left and Ted Edwards Indian Motorcycles is on the far right in this photograph. The center and its two neighboring wooden framed homes were cleared around 1948 to make way for Interstates 75 and 85. The Varsity's growing need for parking eventually prompted Gordy to buy out the businesses adjacent to his restaurant and tear them down.

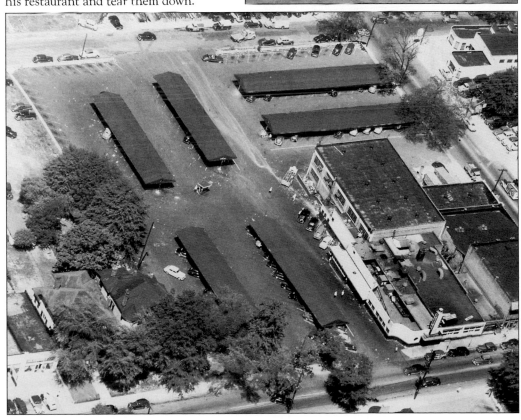

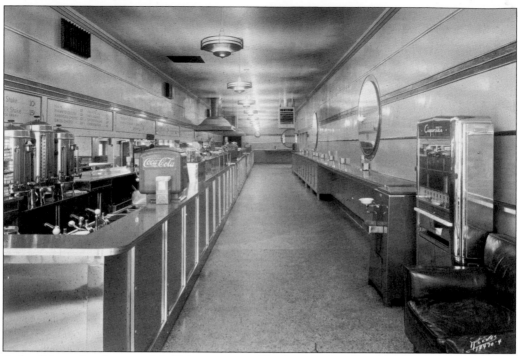

As he did anytime he remodeled his restaurant, Gordy turned to Georgia Power for consultation about how best to light the gleaming new interior. This time, lighting engineer S.J. Andre designed the interior lighting for the remodeled Varsity. The redesign was featured in a Georgia Power newsletter, which lauded the high level of illumination, pointing out that lighting was a "very important feature of a restaurant." Gordy concurred and was quoted as saying the lighting had not only made it easier to see, it had improved employee morale. "You never know how many advantages are wrapped up in modern lighting installation until you have one," he told Georgia Power, adding, "It is therefore easier to serve the customer in less time."

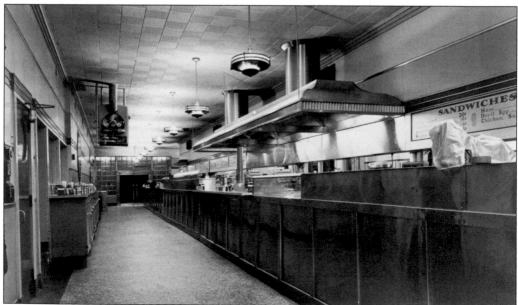

While the great majority of The Varsity's business continued to be outside in its parking lot, the new design helped provide more counter space for customers to stand and eat inside. There were also a few seats here and there. These couches grew to be a coveted spot for many frequent Varsity diners, who would stake them out and use them to socialize.

The local health inspector was quoted in a 1950 article as saying he wished all kitchens were as clean as The Varsity's. The refrigerator shown in this image was also a source of pride. Frigidaire held The Varsity up as an example. Noting the drive-in safely served 10,000 daily, Frigidaire quoted Gordy in advertisements as saying, "To me, the Frigidaire name means dependable products and reliable service."

BEN W. FORTSON, JR.
SECRETARY OF STATE

State of Georgia

OFFICE OF SECRETARY OF STATE

I, BEN W. FORTSON, JR., Secretary of State of the State of Georgia do hereby certify that the trade mark

"THE VARSITY"

Registration No. T-2943

filed in this office on June 26, 1948

has been renewed by The Varsity, Inc.
61 North Avenue, N.W.
Atlanta, Georgia

for a period of ten years and will expire June 26, 1988.

Same has been duly filed and made of record in this office.

IN TESTIMONY WHEREOF, I have hereunto set my hand and affixed the seal of my office, at the Capitol, in the City of Atlanta, this 22nd day of February , in the year of our Lord One Thousand Nine Hundred and Seventy-Eight and of the Independence of the United States of America the Two Hundred and Second .

BEN W. FORTSON, JR. SECRETARY OF STATE.

In June 1948, Gordy trademarked the name "The Varsity," as well as its logo. This is a copy of the papers filed with the State of Georgia. The registration helped protect against others trying to capitalize on the name recognition The Varsity was enjoying. It was good for a period of 10 years, and Gordy made sure that it was reregistered each decade well before the expiration date. At the same time, Gordy also chose to trademark the name of the orange drink concoction he had developed that had become so popular because the name he had given it was linked to the drive-in—he called it "Varsity Orange."

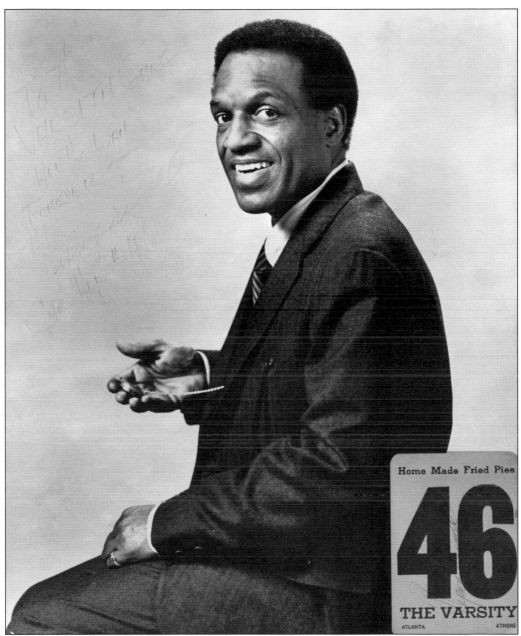

Carhop No. 46 gained his fame not because of his delivery expertise, but because of his comedy. Entertainer Julius "Nipsey" Russell attended Booker T. Washington High School in Atlanta and took a job at The Varsity after he returned from World War II. Russell worked as a carhop at The Varsity for four years, successfully using his comedy skills to increase his tips. He later credited his days at The Varsity with helping him develop his timing. Russell was eventually discovered while working at a comedy club and went on to have a successful stand-up comedy career and star in movies. He periodically checked in with Frank Gordy over the years. His carhop number, 46, is retired.

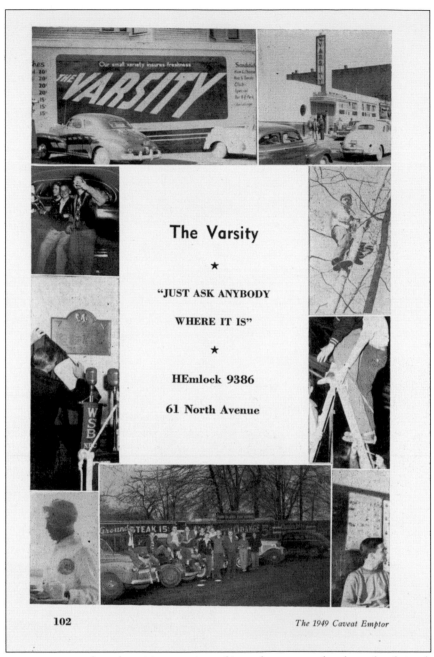

The Varsity

★

"JUST ASK ANYBODY

WHERE IT IS"

★

HEmlock 9386

61 North Avenue

102

The 1949 Caveat Emptor

If one were to turn to the advertising section of just about any school yearbook in the metro Atlanta area from The Varsity's beginning through the 1950s and 1960s, one would most likely find an advertisement for the drive-in. This full-page advertisement is from nearby Decatur's Boys' High School 1949 yearbook, the *Caveat Emptor*. To further its reputation as a supporter of the community, The Varsity encouraged schools to use their own students in the photographs in the advertisements, and this one reflects that practice. The "HEmlock 9386" at the advertisement's center was The Varsity's phone number: 43-9386. In 1953, the Boys' High School merged with the Girls' High School to become Decatur High School. After the merger, the new yearbook was called the *InDecatur*. (DeKalb History Center.)

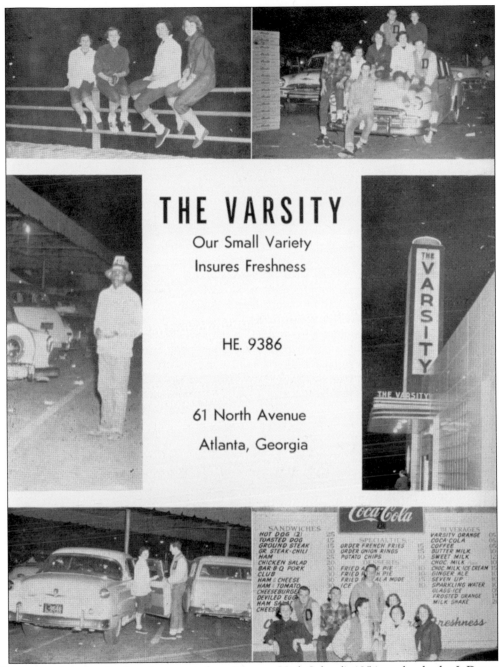

THE VARSITY

Our Small Variety
Insures Freshness

HE. 9386

61 North Avenue

Atlanta, Georgia

This second yearbook advertisement is from Decatur High School's 1954 yearbook, the *InDecatur*. The photographs not only reflect the coed atmosphere of the merged high schools, but also how The Varsity had become a popular teen hangout. It was the place to take dates and the place to try to get a date. For many, making the five-and-a-half-mile drive from Decatur to The Varsity was a weekend, if not a nightly, ritual. But rest assured, Decatur teens were not the only ones making that pilgrimage. The Varsity's reputation as the place to be sparked the catchphrase, "Meet Me at The Varsity." Countless couples have met, courted, gotten engaged, and now bring their children and grandchildren to The Varsity. (Decatur High School.)

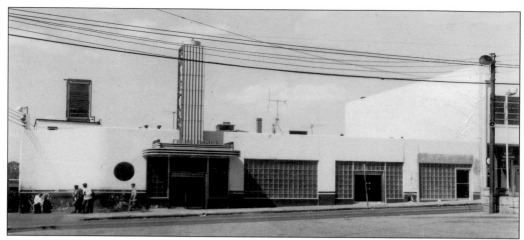

In 1948, Gordy made the decision that his restaurant was more important than The Varsity's Q Room and Barbershop. He closed them down to expand the restaurant and to create two television-viewing rooms. Television broadcasts were still in their infancy. WSB-TV went on air September 19, 1948, in Atlanta, and Gordy felt his customers should be able to watch it as it grew. William Nash was an RCA salesman in Atlanta and a friend of Gordy's. With few televisions available, Nash actually lent Gordy his own personal television from his home. Nash's granddaughter Donna Foster recounts how upset her mother was to come home after school to find their television gone. Foster says her mother lost no opportunity to remind her friend Evelyn Gordy of the "sacrifice" her family had made for The Varsity. (Below, CC.)

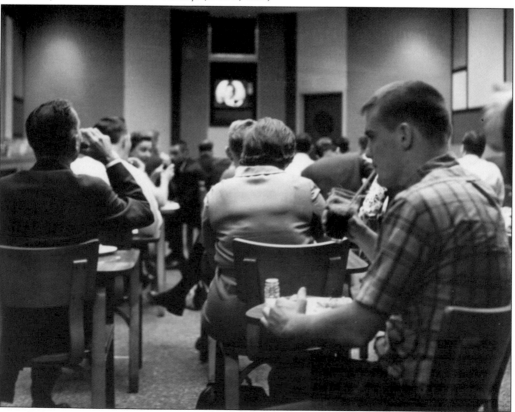

Two

THE WORLD'S
LARGEST DRIVE-IN

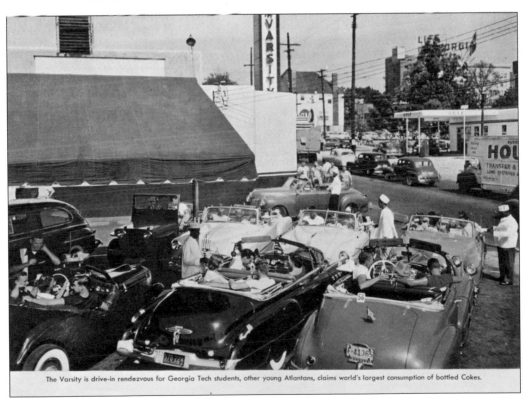

The Varsity is drive-in rendezvous for Georgia Tech students, other young Atlantans, claims world's largest consumption of bottled Cokes.

By 1950, The Varsity had claimed the title of the World's Largest Drive-In. "Meet Me at The Varsity" was catching on. This 1951 *Holiday Magazine* picture offers a glimpse of a typical weekend. Taken from what is now the west side of the drive-in, North Avenue is to the right, a Gulf Oil Station is on the corner, and the Life of Georgia building is in the distance.

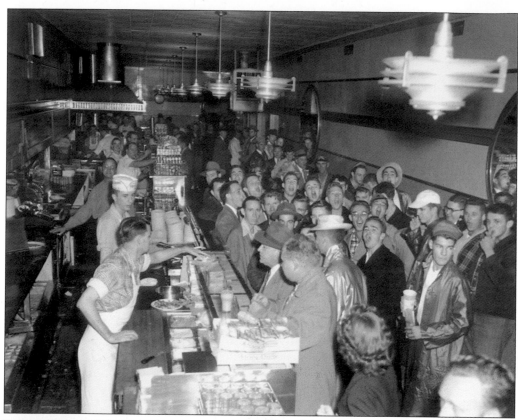

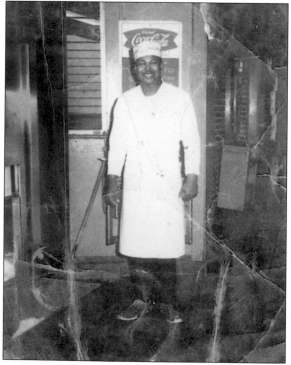

Merita Bread ran this photograph in their 1950 feature on The Varsity. The cheering men are Auburn students celebrating before a Georgia Tech game. The lone woman in the foreground was an unusual sight. Until the 1960s, women rarely ventured inside The Varsity, preferring to have their food delivered outside. Manager Monk Suddath is in the back on the left with his arm extended to the counter. Clifton "Booty" Thompson has his plaid shirtsleeves rolled up. (GSUL.)

Next to John Wesley "Flossie Mae" Raiford, perhaps The Varsity's best-known employee was Erby Walker. Walker came to work at The Varsity in 1952 at the age of 15 and stayed for 55 years. He would later say that he did not ask Gordy how much money he would be making, but how many hot dogs he would be able to eat. (AWT.)

Being a carhop at The Varsity was a coveted job, and by the 1950s, The Varsity employed almost 130 of them. Until the early 1960s, carhops worked entirely for tips, but those added up to more than many people's salaries. *Drive-In Management* magazine reported in 1969 that one curb boy boasted more than $12,000 in tips. (CC.)

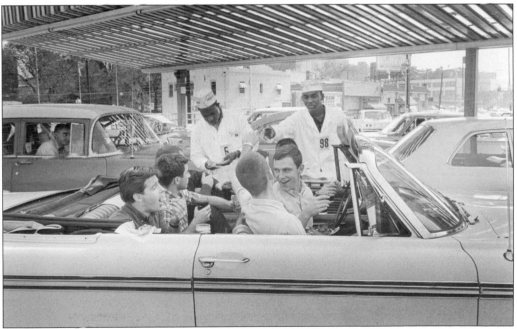

In the 1950s and 1960s, The Varsity parking lot was not just a place to come get food, it was somewhere to hang out and socialize and take dates. There are countless stories about the encounters that took place. Guys who would lean on a girl's car, smoking cigarettes and schmoozing in an effort to impress them, earned the nickname "Fender Lizard." (CC.)

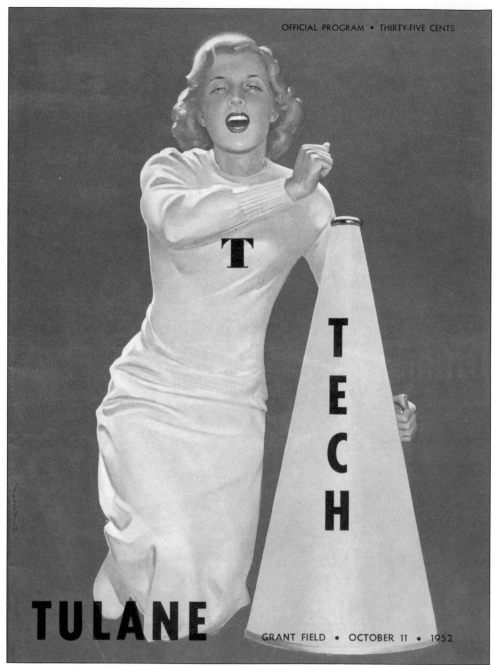

OFFICIAL PROGRAM • THIRTY-FIVE CENTS

TECH

TULANE

GRANT FIELD • OCTOBER 11 • 1952

Above is the Georgia Tech vs. Tulane University football game program from October 11, 1952. It is significant because the imagery is similar to what The Varsity used in most of its advertising campaigns. The Varsity was a supporter of Georgia Tech on every level. The belief was that since Tech students were such supporters of The Varsity, The Varsity should in turn support its neighbor. On football days, fans of both Georgia Tech and the visiting team would more than double the number of daily customers served. Since The Varsity opened, every Georgia Tech sports program and yearbook has held an advertisement for the drive-in. Georgia Tech won this game against Tulane 28-0, finishing the 1952 season as Southeastern Conference Champions. (Tech.)

This advertisement ran inside the Georgia Tech football programs throughout the entire 1952 season. In addition to supporting the school itself through campaigns like this, Frank Gordy also did a lot to help students on a personal level. He employed many of them and, for years, Gordy authorized his employees to cash checks for students because there was no place on campus for them to do so. Often, the checks were not good, but Gordy would cover the amount until he could be repaid. If not, Georgia Tech's president, Dr. Marion Brittain, would help recoup the debt. When Brittain retired in 1944, his replacement refused to get involved. The Varsity stopped the check-cashing practice, and ultimately two banks were built to assist students. (Tech.)

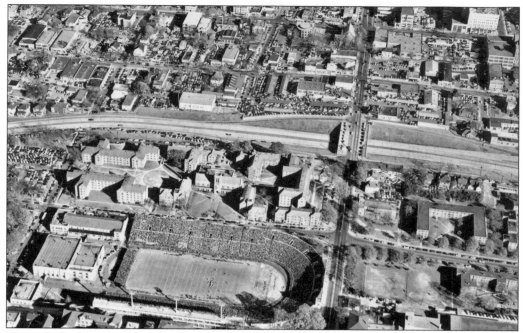

Given the high amount of traffic during Georgia Tech home football games, it is not unusual for the Georgia Department of Transportation to monitor the situation by air. These aerial photographs were taken during Georgia Tech's game against in-state rival the University of Georgia on November 28, 1953. Notice the crowded Varsity parking lot—visible just above the highway at the center of the photograph—and how cars are parked throughout all of the surrounding neighborhoods. Many fans would retreat to The Varsity postgame to wait for traffic to clear. Georgia Tech won this game 28-12. (Both, Georgia Department of Transportation.)

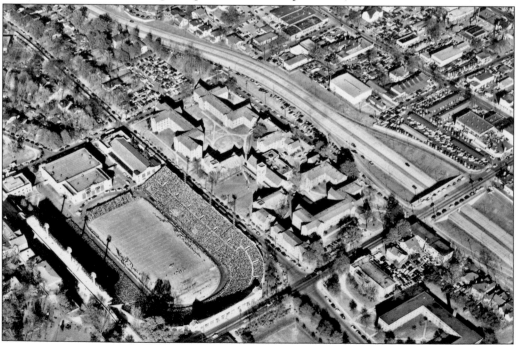

Eventually, the crowds for football games got so large that portions of the west parking lot next to The Varsity's building had to be closed off to handle the crowds. Tables were set up in the lot under the awnings and outdoor order stations were put in place to help the carhops, who worked the crowd on foot. On game days, The Varsity has regularly served more than 30,000 customers, more than double its daily numbers. Georgia Tech's Grant Field was first built in 1913 and is the oldest on-campus stadium in the NCAA. Until 1958, Grant Field sat only 40,000. It was expanded at that time to seat 44,105 and again in 1962 to seat 53,300. With expansions and reductions across the decades, Bobby Dodd/Grant Field's 2011 seating capacity was listed as 55,000.

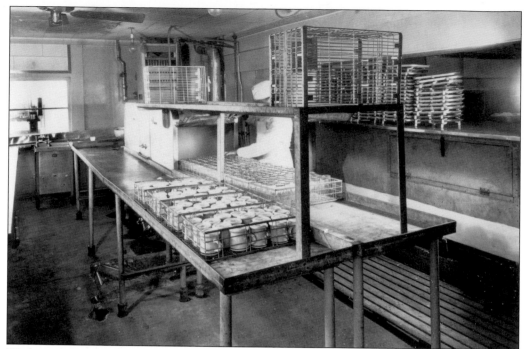

Washing dishes was a beginning job for many Varsity employees, and it was constant work trying to keep up with the volume. While The Varsity food was served on paper plates and taken out in paper boxes, drinks for those dining in or out in the lot were served in real glasses and real coffee cups. The last day Varsity used the glasses, they were given away to customers.

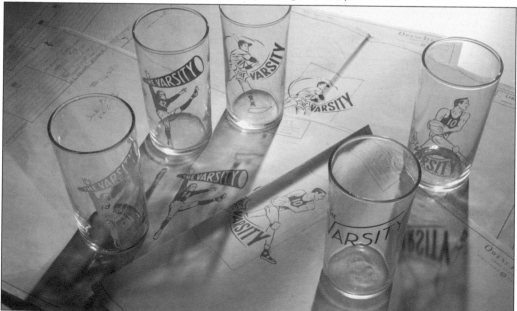

One issue The Varsity dealt with regularly was the loss of glasses that went out to the cars and never made it back—not because of breakage, but because people collected them. Varsity glasses were embossed with images of sports figures and included football, baseball, and basketball. The numbered cards of the curb boys were also a favorite collector's item.

THE MAGAZINE OF COUNTER AND CAR SERVICE

DINER · DRIVE-IN
and Restaurant

A DAVIDSON *Publication*

SEPTEMBER 1954

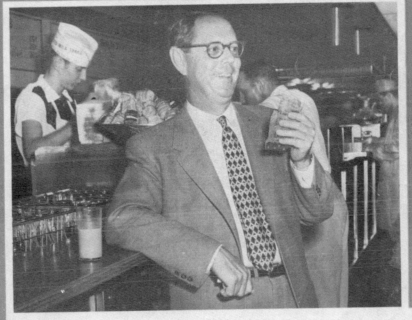

The Varsity—The World's Biggest
Drive-In 10

Pointers on Uniform Care 14

Better Breakfasts With Cereal 16

Mari-Nay III—Bigger and Better 18

Two Ideas 21

POSTMASTER
If addressee has removed
please notify us of new ad-
dress on Form 3547, postage
for which is guaranteed.
405 East Superior St.
Duluth, Minnesota

Sec. 34.66 P.L.&R.
U. S. POSTAGE
PAID
Permit No. 112
Waseca, Minn.

Restaurant industry leaders and vendors were in awe of what Gordy continued to accomplish with The Varsity, and it was the subject of more than one industry publication. This 1954 issue of *Diner, Drive-In and Restaurant* was devoted entirely to The Varsity's business practices and how many employees stayed with Gordy for years. It credited the low turnover of employees to the fact that Gordy "believes in paying a man more than a decent wage." There was also a healthy bonus incentive based on years they worked. He told the magazine, "I once asked them if I could raise their pay and get rid of the bonus, and they said 'no.'" In 2011, carhop Frank Jones had been on the job for more than 63 years.

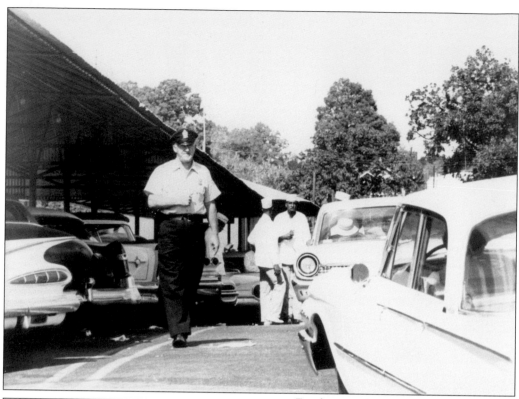

Employing off-duty police officers to help with traffic was a must. The Varsity set records here as well, having the distinction of hiring more moonlighting officers than any other business in Atlanta. Gordy also enjoyed the fact that the officers could keep him informed about happenings elsewhere in the city. Later, he even had a policeman at the Omni complex downtown keep him posted on what was going on.

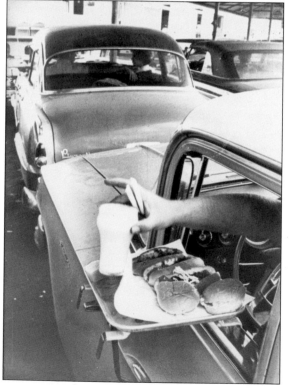

On busy days like the one pictured here, cars would often be two-deep. Parking lot managers helped call out to the carhops where a new customer had parked so no car would go without service. Perhaps the best known among the lot managers was Walter Fuller, a giant of a man with one arm who was also known for keeping unruly customers in line.

The inside of The Varsity was also organized chaos. Gordy's organizational skills in running a kitchen were the stuff trade magazines reported on and other businesses throughout the world studied. Utilizing practices he learned while working packing peaches as a teen, Gordy set up the kitchen and service areas like a factory assembly line, complete with a conveyor belt to deliver hot items. Three cooking stations helped handle the crowds.

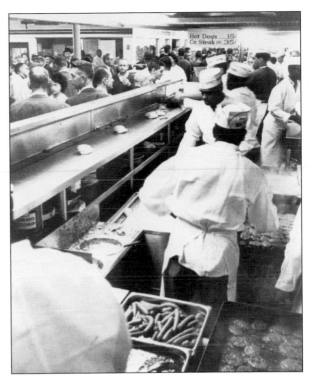

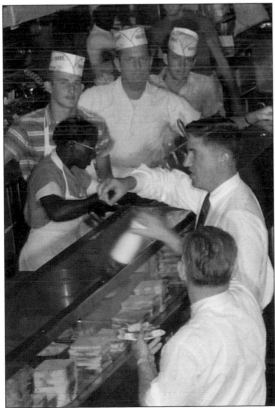

Annie Gresham (at left, behind the counter) was 22 years old when she started working at The Varsity in 1952. Manager George Cook is in the center behind her. Gresham worked there until 1978, when she took time off for her husband's death. She returned to work at The Varsity Jr. that same year and stayed until her death in August 2010.

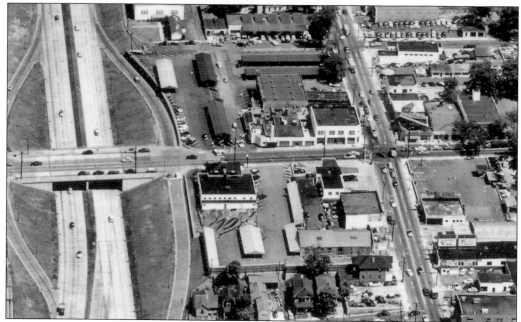

These two photographs show the contrast between The Varsity of 1960 and The Varsity of the late 1980s. The photograph above was taken before Gordy bought out the neighboring businesses and tore them down to make space for more parking. The Varsity itself is the low white building to the north of North Avenue and on the left side of the complex, just to the right of the expressway. Gordy bought out the warehouse in the back and the businesses along Spring Street, giving him about two and a half acres of land for his restaurant and the much-needed parking. The photograph below, from the 1980s, shows the resulting parking areas that surrounded the building after it was remodeled. (Above, Georgia Department of Transportation; below, Chris McLaighlin.)

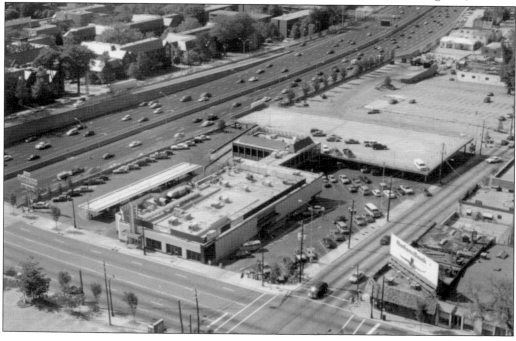

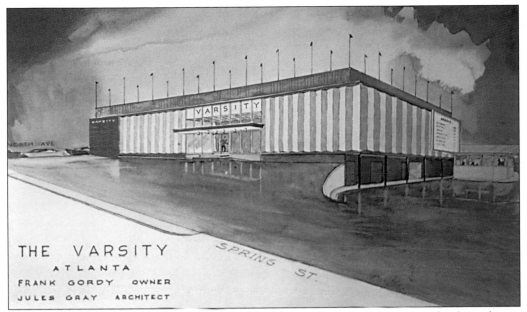

THE VARSITY
ATLANTA
FRANK GORDY OWNER
JULES GRAY ARCHITECT

With the 1960s came another remodeling of The Varsity's exterior. This watercolor, by architect Jules Gray, shows Gray's vision for a new exterior for the building that was designed to last. The plan called for panels made of six-gauge steel with a baked enamel finish to be attached to the existing building.

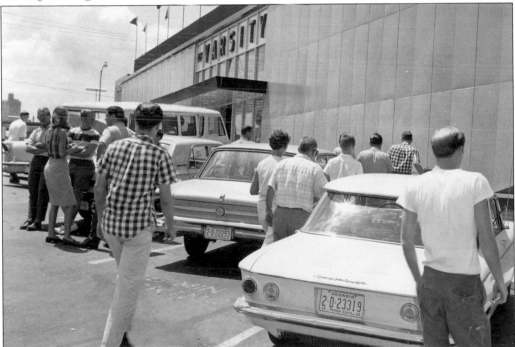

This photograph from 1965 shows a typical afternoon, with teenagers hanging out in the parking lot of The Varsity. The enamel exterior was already a few years old but showing no signs of wear, since the enamel on steel panels makes them virtually maintenance-free. Alternating colors gave the outside of the restaurant a three-dimensional appearance. (AHC.)

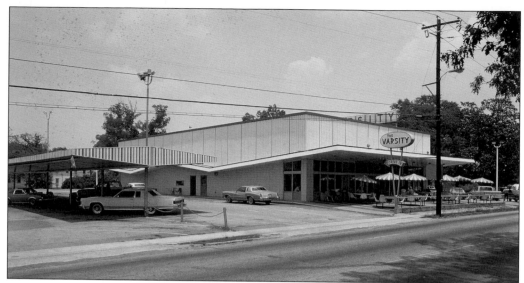

The downtown Athens location had no room to grow, and manager Epp Suddath and Frank Gordy opted to build a second restaurant. The *Athens Banner-Herald* newspaper announced on January 28, 1962, that there would be a new Varsity built on West Broad Street. It opened its doors March 11, 1964, exactly 32 years after the original Athens Varsity.

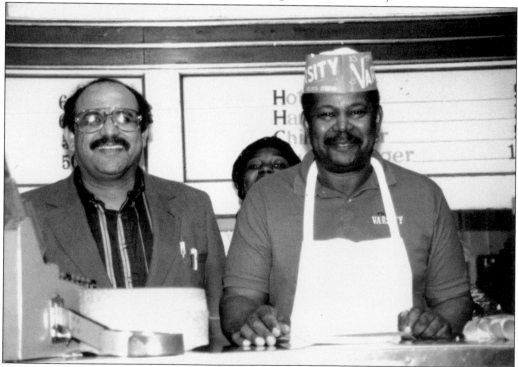

Over the decades, two of the more familiar faces behind the counter at The Varsity were Joe Shalabi and Erby Walker. Both men made the drive-in their careers. Shalabi began work in the 1970s while still attending Georgia Tech. By the time he joined, Walker had already been there two decades. In 1985, when Ed Minix retired as The Varsity's general manager, Shalabi assumed the position, becoming Nancy Gordy Simms's right-hand man. (AWT.)

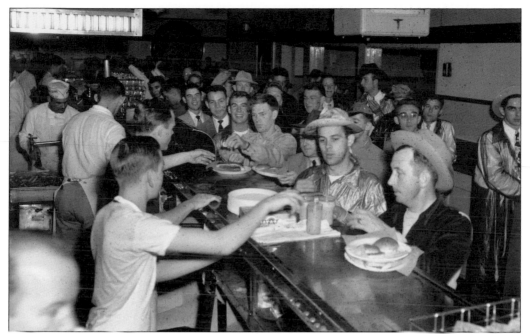

For decades, The Varsity dropped cash into holes in the counter with mayonnaise jars underneath instead of cash registers. Gordy felt it was faster than using cash registers. Even after Joe Shalabi talked him into getting registers (there were only two), *Drive-In Management* reported that during busy times, orders paid for in exact change or with a $1 bill still went into a jar. (GSUL.)

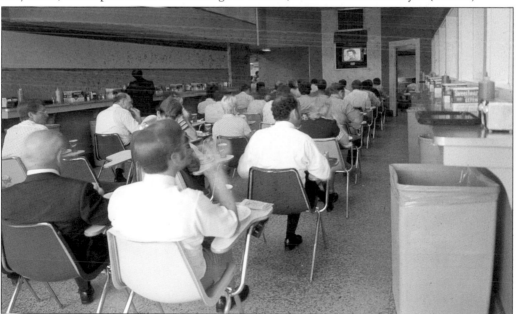

Few households had televisions when The Varsity opened its television rooms in 1949. Merita Bread's company magazine called the concept "innovative," describing the rooms as "very comfortable, and furnished with chairs specially designed by the enterprising Frank Gordy." By 1964, The Varsity had four television rooms, two color and two black-and-white. The fifth television room arrived in the late 1970s. Each room shows a different channel.

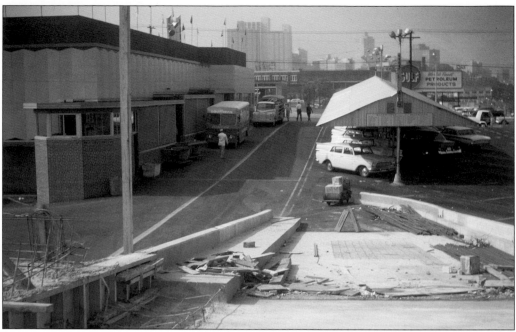

With the ever-growing need for more parking, The Varsity began construction in 1963 on a two-story parking deck in the back lot. Parking decks in general were not common at the time, and to build one for a restaurant was something completely unheard of. Regular customer Troy Nabors is credited with quipping to Gordy that The Varsity would have a "Lunching Pad." Nabors's wit was rewarded with a 30-day pass. The cost of the construction was $210,000, but Gordy felt it was worth every penny. Although the project created some logistical issues while it was underway, the expansion helped The Varsity handle 630 cars, including 500 parked and 130 in motion. The new deck included up and down ramps, which allowed for continual movement of traffic.

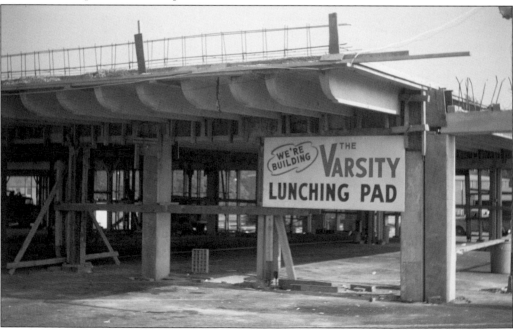

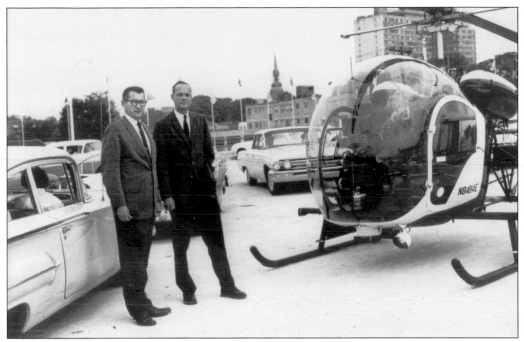

On the day of the Lunching Pad's inauguration, WSB landed its helicopter on the upper deck to much fanfare. Cornfield Meats helped host the party, and Cornfield's Clyde Stinson is pictured here on the left during the festivities with Frank Gordy Jr. One rule put in place for the new deck was that in the evenings, only females were allowed to park up top.

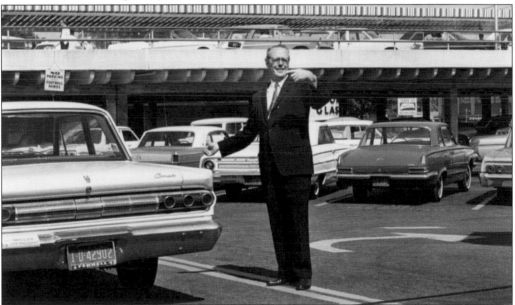

Frank Gordy himself was frequently out directing traffic in the lots, often using a megaphone to alert carhops of a car not being serviced. Always testing the efficiently of his lot, *Drive-In Management* reported he would sometimes have a curb boy carry an order to the far end of the parking lot and back, then eat it to see if customers were getting their hot food hot and their drinks cold. (CC.)

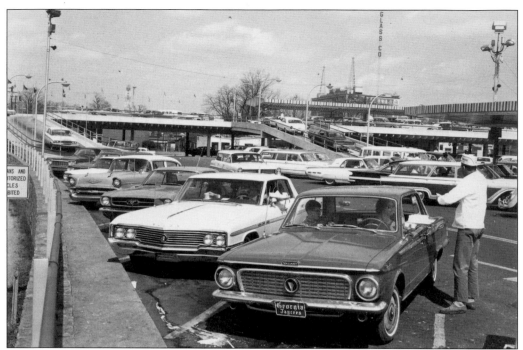

The lot and the Lunching Pad were in constant motion. Curb managers worked to keep the traffic flowing while keeping an eye out for mischief. The lot was so large that the carhops gave the different sections names, like "lower deck," "football" for the lot closest to Georgia Tech, "P Front" for the front, and "Snellville" after a manager named Mr. Snell.

It was apparent early on that The Varsity did not have enough storage or refrigerator space to keep up with the volume of food it was cooking each day. Gordy implemented the motto "No food over 12 hours old," meaning that whatever a customer ate had arrived at The Varsity less than 12 hours earlier. Deliveries from various suppliers came two or three times per day, with drivers often paid on the spot in cash.

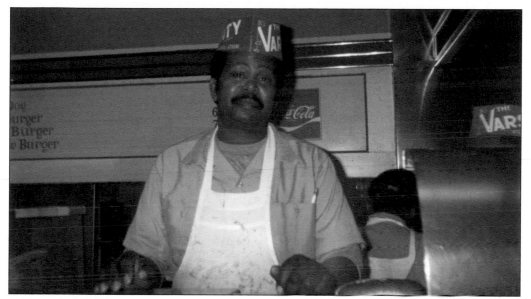

After working in the kitchen and sweeping floors, Erby Walker graduated to the counter in 1964, becoming The Varsity's first African American counterman. He quickly became a fixture by being able to recite the menu, make instant calculations in his head, and keep customers laughing as he kept the line moving along. Many credit him with the slogan "have your money in your hand and your order on your mind." (AWT.)

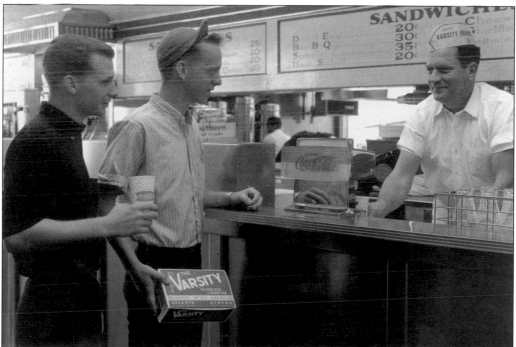

Even though there were seats for more than 200 inside and parking for almost three times that many, The Varsity easily went through 2,000 pop-open carryout boxes per day. Manager George Cook is shown here helping two unidentified customers. A 1988 brochure noted that the single largest take-out order at the time was 1,800 hot dogs and 800 French fries and onion rings. (CC.)

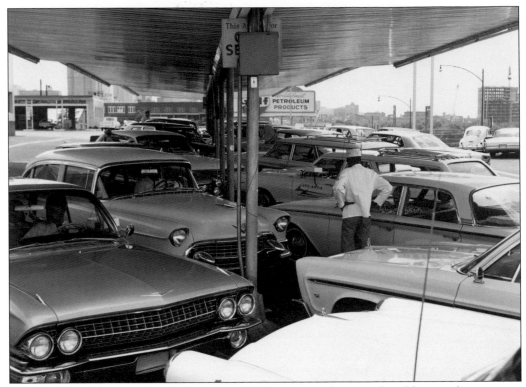

By the 1960s, The Varsity's cloth awnings had long since been replaced by metal structures, which provided more reliable shelter during bad weather and were more durable. In the far right background of this 1965 photograph, one can see construction underway on the Palmer House senior high-rise. The Palmer House was demolished in the spring of 2011.

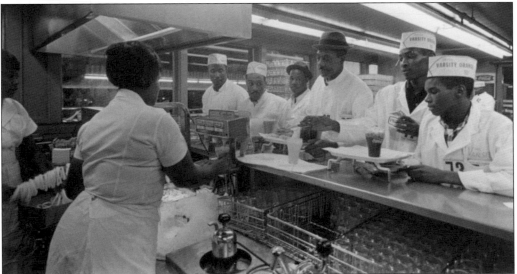

One of the few parts of The Varsity operations that customers could not peer into was where the carhops picked up the orders. Gordy believed that openness gave customers confidence in the freshness of their food and, as it expanded, the rest of the restaurant was designed so that customers could watch much of the meal preparation. (CC.)

In 1961, Georgia House Speaker Tom Murphy started a tradition of having The Varsity cater the final day of the Georgia legislative session. In this undated photograph, Owen Loftin, a longtime doorkeeper at the capital, assists in unloading the food. Speaker Murphy would use the voting machines to have members place their orders—green for hamburgers, red for hot dogs. For pies, green was apple and red was peach.

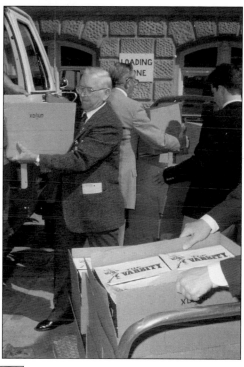

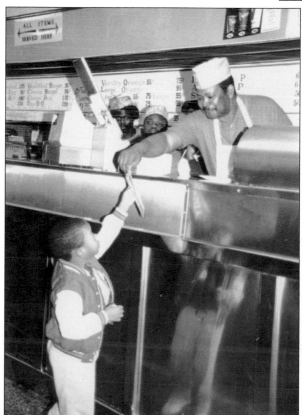

This photograph was one of Erby Walker's favorites. It shows him handing a paper hat to an unidentified small child while his coworkers look on. By then, a large Varsity Orange was priced at 55¢. As Walker neared retirement, he attempted to find the young boy but was unable to do so. (AWT.)

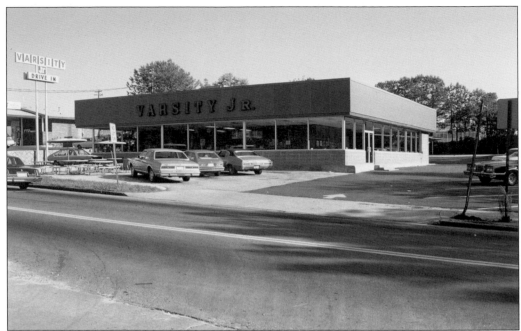

Frank Gordy Jr. worked in finance in New York and had often spoken to his father about franchising The Varsity. Having Varsity restaurants across the nation on college campuses had been Gordy's original dream, but he changed his mind for fear that he would not be able to maintain the food and service standards of which he was so proud. Several times, the senior Gordy almost acquiesced to his son's demands, but he changed his mind every time and said he wanted to keep The Varsity in the family. In 1965, Gordy Jr. forced the issue by purchasing the Raja Drive-in at Lindbergh Drive and Cheshire Bridge Road. The senior Gordy had his attorneys draw up The Varsity's only franchise license and The Varsity Jr. was born.

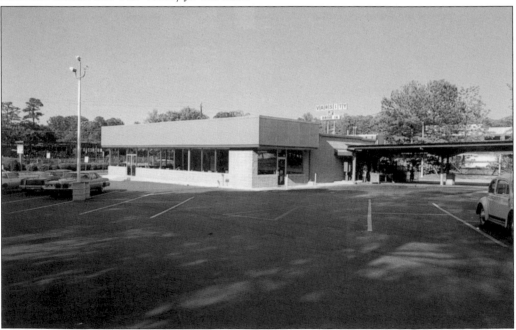

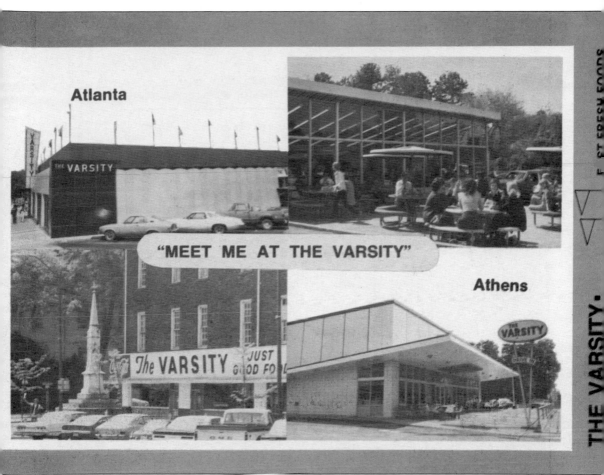

This advertisement for all four of The Varsity locations appeared in the June 1976 *Guide to Georgia*, a publication distributed in Georgia welcome centers across the state. The original Varsity is shown at top left. At top right is The Varsity Jr. On the lower half of the advertisement, the original downtown Athens location is on the left and the Broad Street restaurant is on the right. The quarterly *Guide to Georgia* highlighted businesses and activities that visitors might want to check out while visiting the state. The issue containing this particular advertisement also featured an article about the Atlanta Jazz Festival, held June 25 and 26 of that same year.

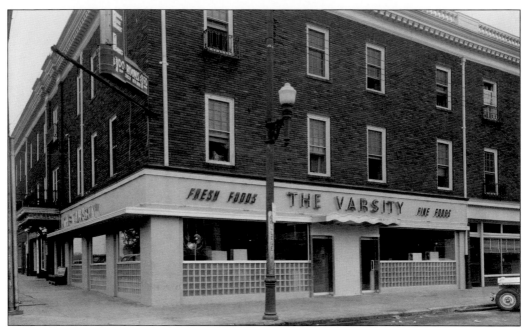

While the Athens Varsity was popular, it was never able to rival the business done by the original in Atlanta. In the 1970s, the University of Georgia moved many of its dorms across campus and business dropped in the downtown Varsity location on College Street. The downtown Athens Varsity closed on December 28, 1978, while the Broad Street location remained open.

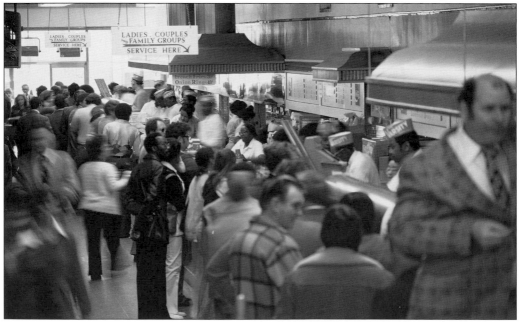

Maintaining efficiency along the 145-foot serving counter meant dividing it into areas to serve different groups of customers. In this photograph, on the left at the far end, were areas designated for ladies, families, and groups. The right side was known as "The Country Store" because most of the employee working the area came from outside Atlanta in the country. Erby Walker became the manager of the Country Store and became famous running its express line.

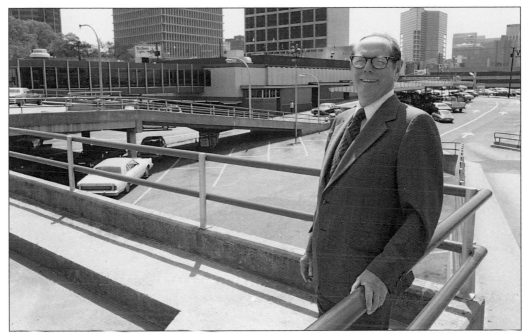

Frank Gordy is pictured on the Lunching Pad in 1978 with The Varsity's latest addition over his right shoulder. The bridge to the Lunching Pad and a fifth television room expanded The Varsity by adding tables and chairs for 92 people, plus 68 feet of standing counter space. The bridge allowed diners to eat with a view of either Spring Street or the expressway and Georgia Tech.

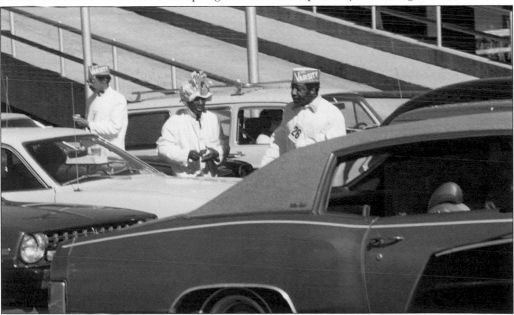

This 1970s-era photograph shows how busy the parking lot would become during lunchtime. The car hops shown here include two of The Varsity's best known and longest serving. To the left is Frank Jones, who started in 1948. In the center is John "Flossie Mae" Raiford, who started in 1937 and worked 57 years before retiring at the age of 87. The name of the No. 26 car hop to the right is unknown.

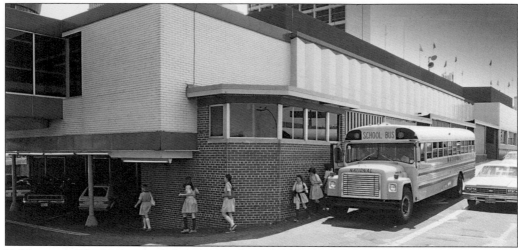

Field trips to The Varsity by Atlanta area schoolchildren have been a tradition since the 1960s. The photograph above shows the arrival of a group of students from Lovett School in Atlanta, while the image below shows a different group learning the art of sandwich making. More than a dozen school buses have been known to visit the drive-in at a time. While students may come with their hearts set on dining, the field trips are not just for eating. Students not only learn about cooking and serving the food, they get a lesson in the efficiency of The Varsity operations—the same operations that have been studied on an international level by businessmen making similar pilgrimages.

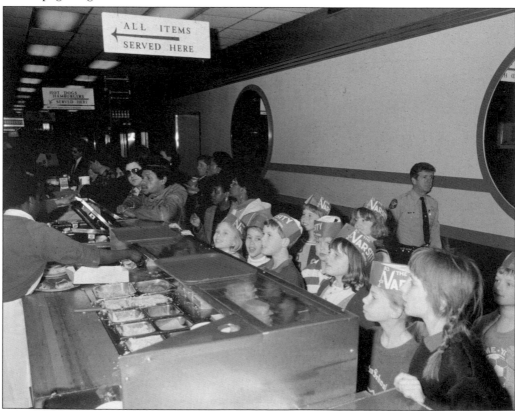

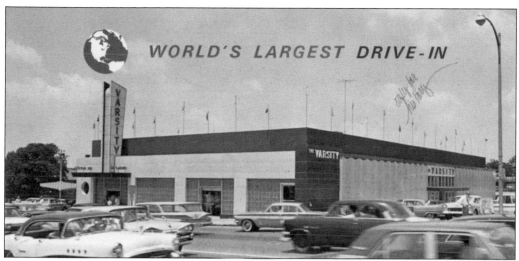

These two brochures were an expensive undertaking but something Gordy felt was needed to help spread the word of The Varsity. The brochure above was printed in 1969, while the one pictured below was printed in 1978. *Drive-In Management* magazine was impressed enough by the initiative that they wrote about the 1969 brochure, describing it as having 20 pages of four-color photographs. Gordy defended the expense, saying the brochure was The Varsity's best advertising and that "people have carried them to every part of the United States" and throughout the world. The response from the first one was so popular that for The Varsity's 50th anniversary in 1978, a newer and even more elaborate brochure was created. In it, Gordy declared that "The Varsity is an institution, it's the most loved restaurant in the world."

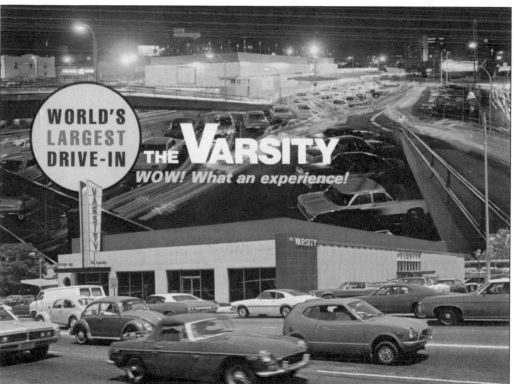

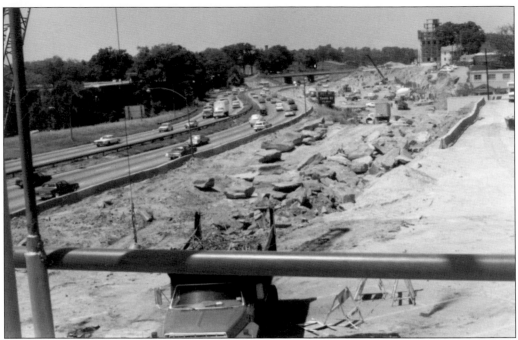

In the early 1980s, Atlanta's population had topped two million and growing traffic issues required a widening of the Interstate 75/85 connector that borders The Varsity. These photographs show the work that was already underway to change a four-lane expressway to an eight-lane. The bridge in the distance of the image above is Tenth Street. Because the interstate was built right next to The Varsity, the widening project required part of the drive-in's land and therefore part of the Lunching Pad. The section that Frank Gordy is standing on shows the Lunching Pad after it had already had the outside down-ramp removed to make way for the interstate development. Gordy was in his late 70s at the time and concern was growing about The Varsity's future.

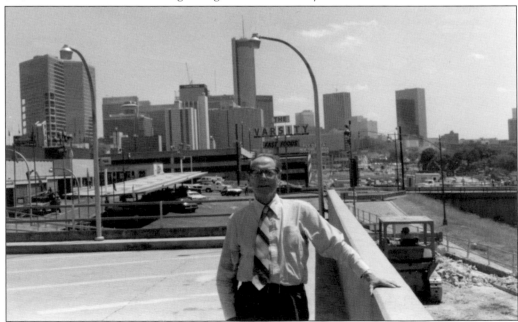

Three

MR. VARSITY

Frank Gordy was born in 1904 in Thomaston, Georgia, to farmers Robert and Kate Gordy. When his father died, Gordy's mother moved her four children to nearby Waleska, where she taught music at Reinhardt Academy (now Reinhardt University). It was there that Gordy met Evelyn Jackson, who would later become his wife. She was just 13 years old and too young to date, but those early encounters made a lasting impression on both of them.

When Gordy finished at Reinhardt, he enrolled at Georgia Technical College (now the Georgia Institute of Technology). His uncle had gone there, and his mother encouraged him to go, too. Majoring in industrial management, he lasted only a semester. He admitted he was not a great student, but the legend that he flunked out is not true. He transferred to Oglethorpe College to finish the year, predicting to his roommates that he would make $20,000 before they graduated.

Gordy headed to Orlando with his brother Herbert in their Buick convertible to try their hands at real estate. While there, Frank became fascinated with restaurants that served food quickly. When taking a train trip to Ohio, he stopped in Atlanta to visit his uncle Bob Ingram. It was then that he saw the shack that would become the Yellow Jacket. He never made it to Ohio.

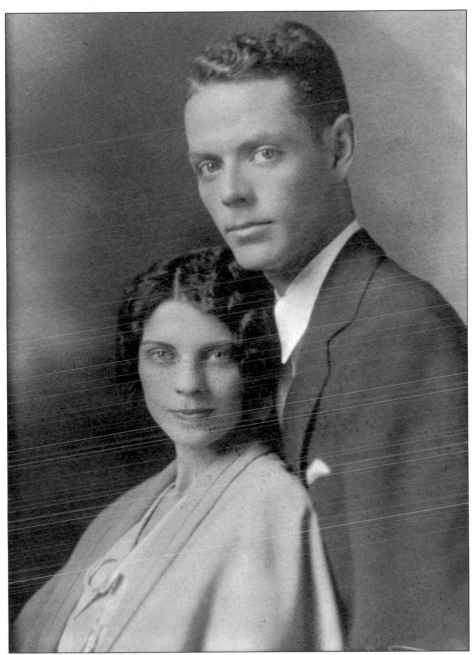

When Frank Gordy moved back to Atlanta, Evelyn Jackson had graduated Reinhardt and was also living there. She was working at the G.I. Miller Company downtown in the Hurt Building. Frank had opened the Yellow Jacket, and friends let him know Evelyn was also in town. He asked her out, and the two dated for almost three years. By 1930, The Varsity was proving successful and Gordy was financially secure enough that he asked Evelyn to marry him. They wed July 7, 1930. This is Frank and Evelyn Gordy's wedding portrait. By the time the two married, he was worth more than $40,000—double the bet he had made with his Tech roommates. The car mural found on the landing between the counter and the bridge depicts the car they drove on their honeymoon.

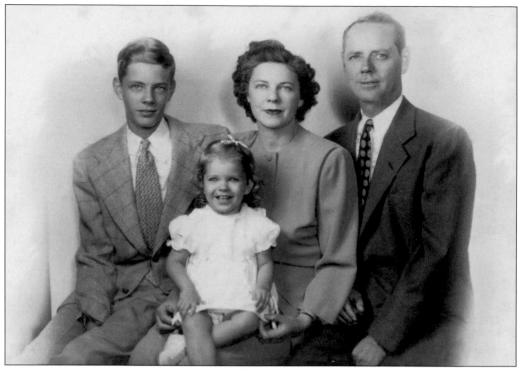

Frank Jr. was the first child to come along, followed by Nancy. While Frank Sr. built The Varsity empire, Evelyn kept the house and raised the family. In fact, Frank turned over the profits from the barbershop for Evelyn to use for the house and to buy groceries. When Frank decided to open The Varsity in Athens in 1932, he ended up borrowing the money from the funds Evelyn had saved.

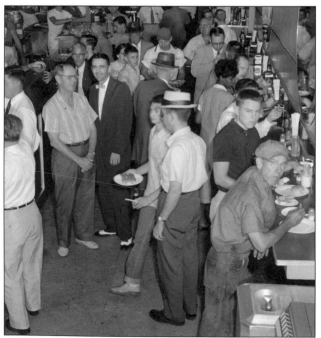

Nothing suited Gordy more than being out among his customers. He is shown here in 1955, wearing a short-sleeved, striped shirt and standing in the middle of a lunch crowd. Each day, he would tell his employees, "Let's make everybody happy who comes in here," and with the ever-present smile on his face, he personally did his best to see that it happened. (GSUL.)

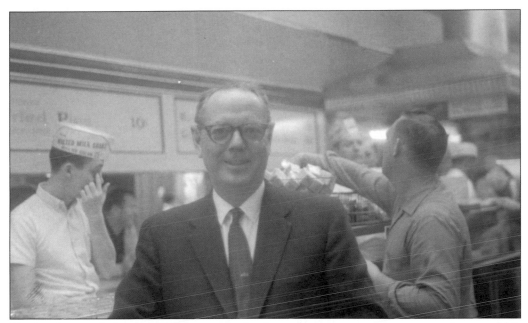

Gordy often said that he threw away the books on how to run a restaurant and created his own formula. His basic philosophy was to serve the best food at the lowest prices and as fast as humanly possible—oh, and to enjoy it while doing so. He never wanted to lose his personal touch with customers.

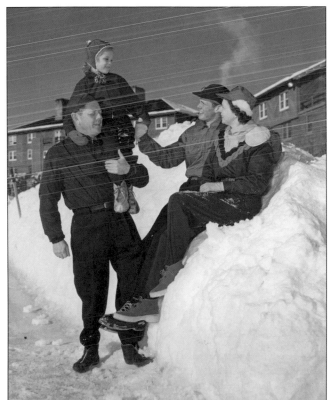

Two things Frank Gordy enjoyed as much as working at The Varsity were spending time with his family and experiencing the great outdoors. Sun Valley, Idaho, was a favorite destination that allowed him to do both. He is pictured here in the 1950s with Nancy, Frank Jr., and Evelyn while on a ski vacation in Sun Valley.

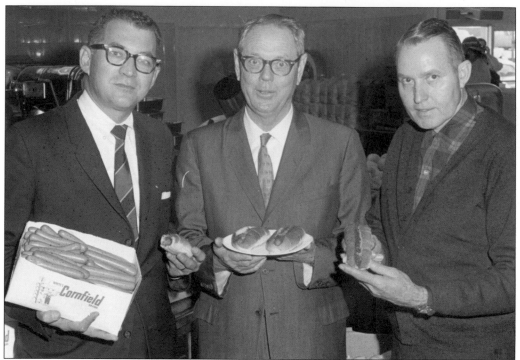

As much a showman as he was a businessman, Frank Gordy often said that he had "million dollar taste buds" and claimed to have a doctorate in "hamburgerology and hotdogology." No product came through The Varsity without undergoing his personal inspection. Cornfield Meats' Clyde Stinson was charged with maintaining the quality and taste of The Varsity's hot dogs. Stinson (left) and Gordy (center) are shown here tasting hot dogs with manager Ed Minix.

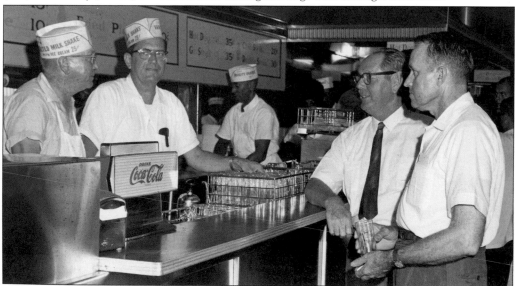

General manager Ed Minix was Gordy's right-hand man throughout the growth of The Varsity. Shown here with day manager Johnny Hutchinson (left) and evening manger George Cook (center), Gordy (in front of counter, wearing glasses) and Minix confer with the two about operations. The Varsity functioned and still functions as both a business and a family.

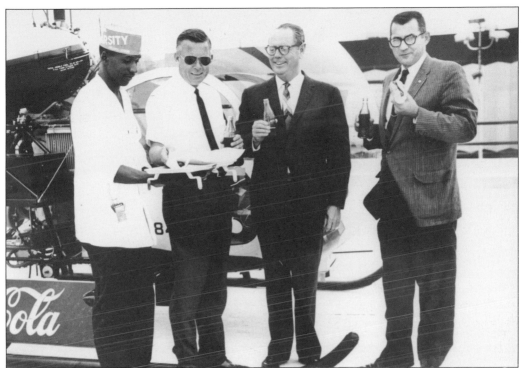

In 1962, the World's Largest Drive-In got even bigger with the addition of a new parking deck. With the US space program now in its heyday, Gordy decided to call the addition the "Lunching Pad" in its honor. For the inauguration, WSB's helicopter used the Lunching Pad as a landing pad. Pictured here are, from left to right, Rufus Cook, pilot Deforest Kenemer, Frank Gordy, and Cornfield Meats' Clyde Stinson.

Frank Gordy was forever out in the parking lot, watching the action and making friends. It was so common to see him outside that few realized that his walks that diverted off Varsity property were to make the daily bank deposit. Gordy would have thousands of dollars in his pocket while making the two-block walk unnoticed. (GSUL.)

Frank Gordy Jr. began his career as a securities analyst in New York, but by 1965, he was hoping to talk his father into franchising The Varsity. Frank Sr. refused. At age 33, Gordy Jr. returned to Atlanta and purchased noted architect John Portman's first creation, the Raja Drive-in. His father granted him The Varsity's only franchise license and The Varsity Jr. was born.

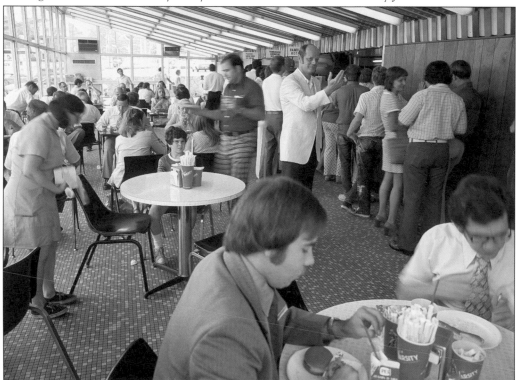

The Varsity Jr. proved to be such a success on opening day that it had to close early because it could not handle the crowds. Soon it, too, would expand, eventually doubling in size. Frank Jr. ran The Varsity Jr. until his death in 1980, when his wife, Susan, took over operations. The Varsity Jr. closed in 2010 because of zoning issues.

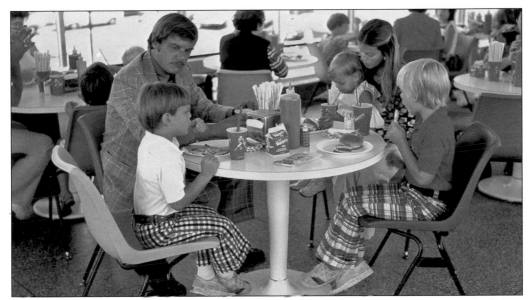

This photograph was taken for The Varsity's 50th anniversary brochure in 1978, and while it seemed like any Varsity family, it was the Varsity family. On the table's left are Nancy Gordy's then husband Doug Muir and their son Michael. On the right side of the table are daughter Carrie Muir, Nancy, and son Gordon Muir. Gordon was 17 when he took his first job in the family business, working the grill at The Varsity Jr.

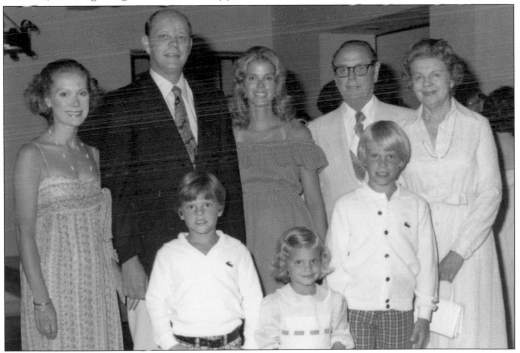

This Gordy family picture was taken in the 1970s at the Cloisters Resort in Sea Island, Georgia. They are, from left to right, Susan Hunter Gordy, Frank Gordy Jr., Nancy Gordy, Frank Gordy Sr., and Evelyn Gordy. The children in front of the adults are Nancy's. From left to right, they are Michael, Carrie, and Gordon Muir.

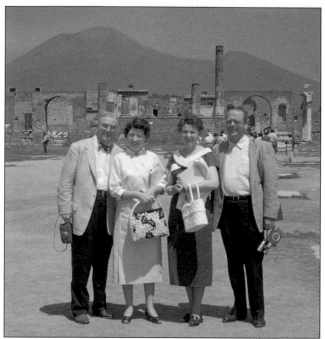

The success of The Varsity allowed the Gordys to indulge their love of travel. When they first married, trips were taken by car, usually to New York or Florida. But increasingly, they ventured farther from home. Evelyn encouraged her husband to take a break from the business that had become his life. In the 1960s-era photograph at left, they are in Pompeii, Italy, with friends Ruth and Willie Cox. In the image below, they are in New England. Frank was torn between his love for adventure and his love for The Varsity. He told friends and reporters that he was miserable when he was away from his business. As he proclaimed in his own brochure in 1978, "I love it . . . it's my life."

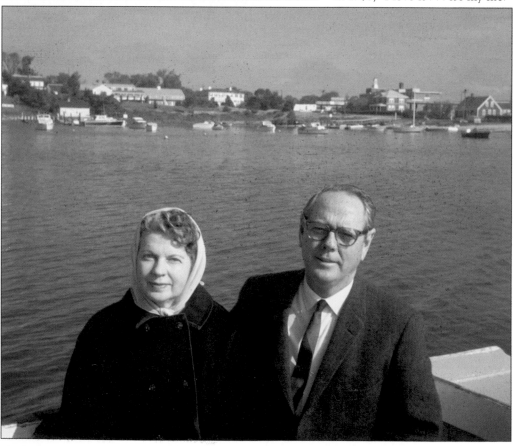

Frank Gordy poses for a brochure photograph while in the crosswalk to the Lunching Pad soon after it was built in 1978. By then, he was in his 70s and feeling effects of emphysema and eventually began missing work. Frank Gordy passed away at his home on June 18, 1983, at the age of 79, having founded The Varsity 55 years prior and having been married to his beloved Evelyn for 43 years.

Services for Frank Gordy were conducted three days after his death at Peachtree Road United Methodist Church. On that day, The Varsity locked its doors to allow employees and customers to attend. June 21, 1983, is noted as the first day in more than 20,000 consecutive days that the doors of The Varsity were not opened for business.

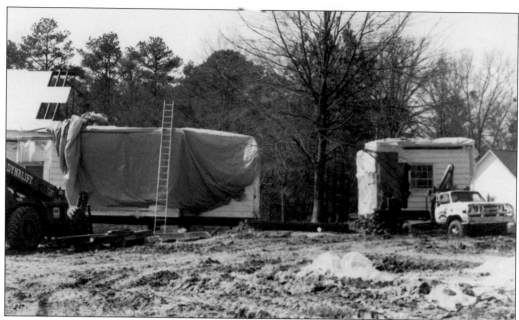

In October 1940, Frank Gordy bought his wife, Evelyn, a home on Piedmont Road house as a Christmas present. It was here that they raised their children and entertained their grandchildren. Friends and family described visiting the home as "going to camp." The children had a virtual menagerie of pets. Over the years, daughter Nancy had 13 cats, five dogs, ducks, and a pony. The Gordys lived there until Frank's death in 1983. When Evelyn decided that it was time to move, she could not bear the thought of selling the home or tearing it down. Instead, she donated it in 1990 to her and Frank's alma mater, Reinhardt University (previously Reinhardt Academy), to be used as a hospitality house. The home was divided into four sections and moved 50 miles to Waleska, Georgia. Evelyn Gordy personally oversaw the work and poses in the photograph below with the completed home at Reinhardt. (Both, Reinhardt University)

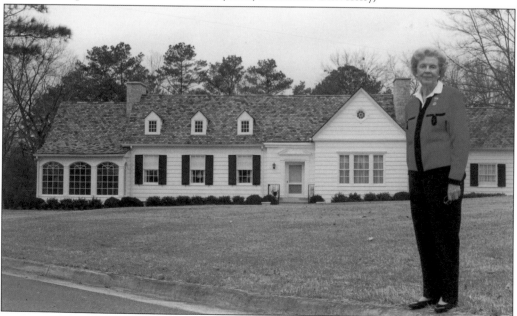

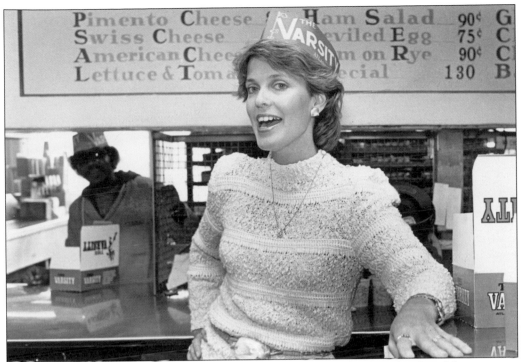

When Frank Gordy's health began to fail, his wife, Evelyn, told their daughter Nancy it was time to decide The Varsity's future. Frank Jr. had preceded his father in death, and running The Varsity was the last thing the mother of three had expected to be doing. Nancy met with manager Ed Minix and soon found herself on kitchen duty. Minix predicted she would not last. She proved him wrong.

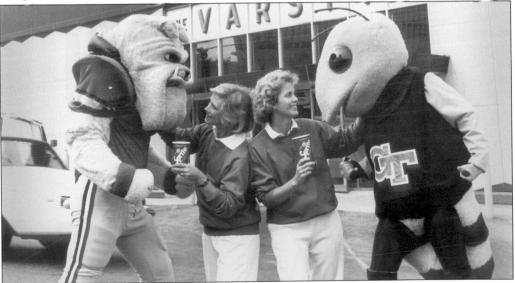

While Nancy Gordy Simms ran The Varsity downtown after her father's death, her sister-in-law, Susan Hunter Gordy, ran The Varsity Jr. on Lindbergh Drive. The two are shown here with the mascots of rival schools University of Georgia and Georgia Tech. Susan offers a Sprite to the Georgia Bulldog while Nancy offers one to Georgia Tech's Buzzy.

To honor her late husband, Evelyn Gordy-Rankin oversaw the design and construction of a multimillion-dollar dining hall at their alma mater, Reinhardt University. She reportedly ate lunch off sawhorses as she attended to every detail. The chandelier in the hall was one she salvaged when the Sears on Ponce De Leon Avenue in Atlanta closed. The Gordy Center opened on October 26, 1984. (Reinhardt University.)

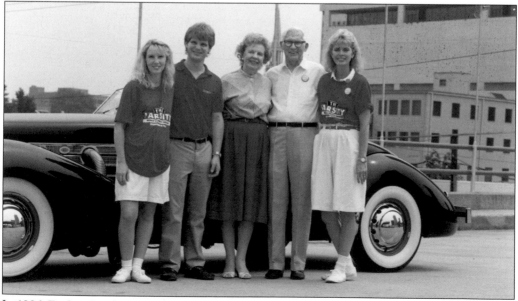

In 1986, Evelyn Gordy married longtime friend Olney Rankin but continued to be involved with the operations of The Varsity. This 1988 photograph shows the family on the Lunching Pad at The Varsity's 60th anniversary party. From left to right, they are Sally Muir, Gordon Muir, Gordy, Rankin, and Nancy Gordy Simms. Olney Rankin passed away in 1994.

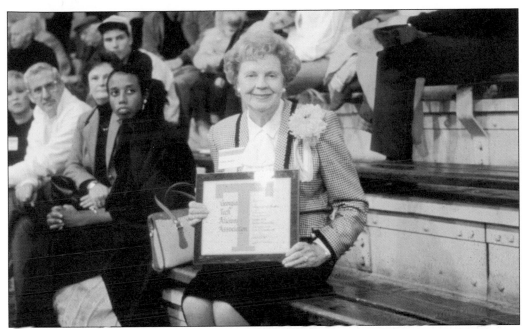

In 1989, Evelyn Gordy-Rankin donated $1 million to the Georgia Tech Centennial campaign in memory of her late husband, Frank. The money was specifically pledged toward a dining area in the Wardlaw Center. The new hall was named the Frank Gordy Dining Hall. That same year, she was named an honorary alumna of Georgia Tech.

Three generations are photographed here during The Varsity's 60th anniversary celebration in 1988. Standing in the celebration's gift area are, from left to right, Carrie Muir, Nancy Gordy Simms, and Evelyn Gordy-Rankin. The huge celebration saw the launch of a Varsity memorabilia line and included a giveaway of a red Mustang convertible.

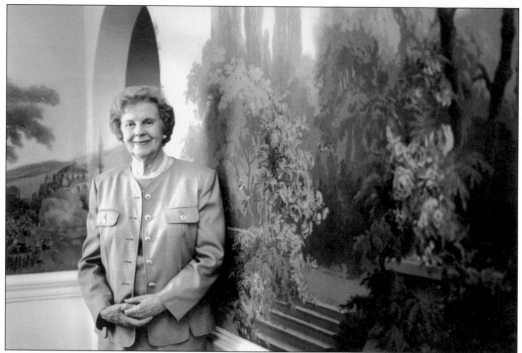

Evelyn Gordy-Rankin continued her philanthropic work for decades after she lost both husbands. This photograph was taken in front of the restored wallpaper of the house she shared with Frank Gordy that is now the hospitality home at Reinhardt. The artist she hired to work on the wallpaper lived in the home until it was completed to her satisfaction.

While Nancy Gordy Simms never got the opportunity to work alongside her father, she did have the benefit and counsel of her mother. Evelyn Gordy-Rankin served as chief executive officer of The Varsity. She attributed her long life and great complexion to eating Varsity hot dogs. She passed away on October 31, 2006, at the age of 99, never having lost her taste for Varsity chili dogs, red steak, and hot apple pies.

Four

WHAT'LL YA HAVE?

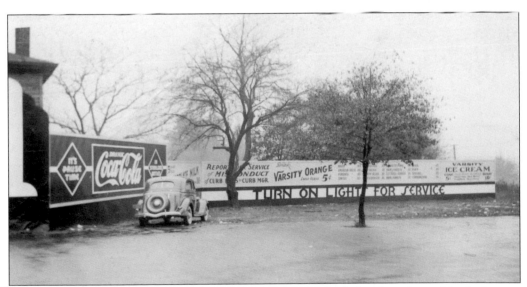

This large Varsity menu was painted on the fence of its expanded parking lot on North Avenue in 1937. While a few items are no longer sold, the core offerings of The Varsity have changed little since Frank Gordy first opened the restaurant in 1928. A stickler for taste, he felt that by keeping the menu simple, he could assure the quality of all of his food.

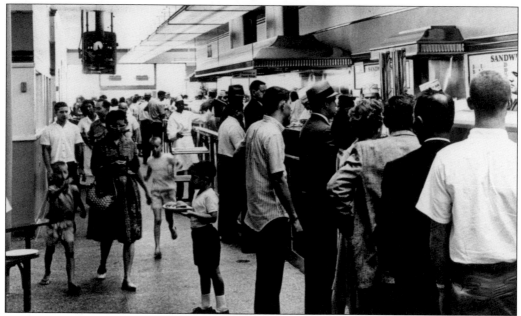

From the moment a customer walks in the door of The Varsity, they are greeted by a shout of, "What'll ya have?" The chant originated early from the sheer enthusiasm of the countermen trying to serve an ever-growing crowd of customers. This picture from the 1950s shows a typical lunchtime crowd.

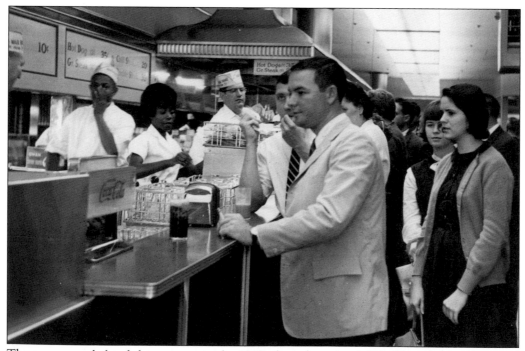

The menu seen behind this counter in the 1940s shows how simple The Varsity menu remained even as the drive-in grew. Frank Gordy often said he had "million dollar taste buds." As he developed his menu for The Varsity, he stuck with what tasted good to him—and what tasted good to him worked. (CC.)

THE VARSITY
TRADE MARK REGISTERED

17

SANDWICHES	Price			Price
Hot Dog (2)	25c		Varsity Orange	5c
ToastedDog	15c		Coca-Cola	5c
Ground Steak	15c		Coffee	5c
Gr. Steak, Chili	20c		Buttermilk	10c
Ham	25c		Sweet Milk	12c
Chicken Salad	20c		Plain Choc. Milk	10c
Barbecue Pork	30c		Choc. Milk, Ice Cr.	15c
Club	30c		Ginger Ale	10c
Ham and Cheese	30c		Seven Up	10c
Ham and Tomato	30c		S-water, ice	15c
Cheeseburger	25c		Frosted Orange	15c
Deviled Egg	20c		Milk Shake	20c
Ham Salad	20c		Premium Beer	30c
Pimento Cheese	15c			
Swiss Cheese	15c			
American Cheese	15c			
Order French Fries	15c			
Order Onion Rings	15c			
Potato Chip	10c			
Fried Apple Pie	10c			
Fried Peach Pie	10c			
Fr. Pie a-la-mode	15c			

Make of Car_____ **THE VARSITY** No._____
TRADE MARK REGISTERED

THE FUN PLACE TO EAT

SANDWICHES	No.	Price	Total	BEVERAGES	No.	Price	Total
Hot Dog (2)		45c		Big Orange		15c	
Ground Steak (2)		45c		Varsity Orange		10c	
Chili Steak		25c		Coffee		10c	
Glorified Steak		35c		Buttermilk		15c	
Cheese Steak		35c		Sweet Milk		15c	
Double Steak		40c		Plain Choc. Milk		15c	
Ham		35c		Lg. Choc. Milk		20c	
Chicken Salad		30c		Regular		25c	
Barbecue Pork		45c		Frosted Orange		25c	
Special		45c		Milk Shake		30c	
Ham and Cheese		45c					
Ham and Tomato		40c		DESSERTS			
Deviled Egg		30c		Fried Apple Pie		15c	
Ham Salad		30c		Fried Peach Pie		15c	
Pimiento Cheese		30c		Fr. Pie a-la-mode		25c	
Swiss Cheese		30c		Ice Cream		10c	
American Cheese		30c		Double Dip		20c	
SPECIALTIES				CIGARETTES			
French Fries		20c					
Onion Rings		20c					
Potato Chips		10c					

PLEASE NOTE
Curb boys are now under Wage & Hour Law
SERVICE CHARGE
Bills to $1.00 — 10¢, up to $2.00 — 20¢, maximum — 30¢
THE MANAGEMENT

Try a Varsity Orange

Carhops were assigned a number and had corresponding numbered menu cards to give to their customers. The Varsity menu has changed little over the years, but note the differences in the prices on menu card No. 17, from the 1930s, compared to No. 21, from the early 1970s. The menu sheet with no number is from 1963 and was for those who ventured inside to place their orders. The numberless sheets were rarely used because of the fast pace and calls of the counter staff. Regulars knew that upon entering The Varsity, they should "have your money in your hand and your order on your mind." Card No. 21 still lists items such as "sweet milk" and "buttermilk." Gordy included buttermilk on menus because he liked the taste of it, but it was removed around 1990. Deviled eggs were popular in the 1930s, but not so much in later years. They were removed after 2007.

THE VARSITY
THE FUN PLACE TO EAT

21

SANDWICHES	Price			Price
Hot Dog (2)	55c			
Ground Steak (2)	55c			
Chili Steak	30c			
Glorified Steak	40c			
Cheese Steak	40c		BEVERAGES	Price
Double Steak	50c		Big Orange	20c
Ham	45c		Varsity Orange	15c
Chicken Salad	45c		Coffee	15c
Barbecue Pork	50c		Buttermilk	20c
Special	55c		Sweet Milk	20c
Ham and Cheese	55c		Plain Choc. Milk	20c
Ham and Tomato	50c		Lg. Choc. Milk	25c
Deviled Egg	35c		Regular	25c
Ham Salad	30c		Frosted Orange	25c
Pimiento Cheese	35c		Milk Shake	30c
Swiss Cheese	30c		DESSERTS	
American Cheese	30c		Fried Apple Pie	15c
SPECIALTIES			Fried Peach Pie	15c
French Fries	25c		Fr. Pie a-la-mode	30c
Onion Rings	35c		Ice Cream	15c
Potato Chips	10c		Double Dip	25c

Try a Varsity Orange

The hot dog has reigned supreme among The Varsity's signature menu items. The first dogs were supplied by White Meats, with later hot dogs coming from Cornfield. Gordy was a perfectionist when it came to the taste of his hot dogs, ultimately requiring they have a specific recipe. Cornfield brought Gordy several samples, and he chose the "Varsity Dog." While meat suppliers have changed over the decades, the hot dog recipe has remained constant.

Another staple since the early menu is the Varsity Orange. Gordy wanted to include an orange-flavored drink and searched extensively for just the right taste. While traveling to Coney Island with his wife, he found a recipe he felt was close to what he wanted and tweaked it when he got back to Atlanta. The Frosted Orange or F.O. is Varsity Orange mixed with ice cream.

Gordy also refused to skimp on the quality of meat in his hamburgers and chili. He insisted on using top-grade meat and could tell the difference simply by tasting. The sheer volume of meat sold daily at The Varsity in Atlanta reached unheard-of numbers. By 1963, trade magazines were reporting that The Varsity went through 10 tons of meat per week.

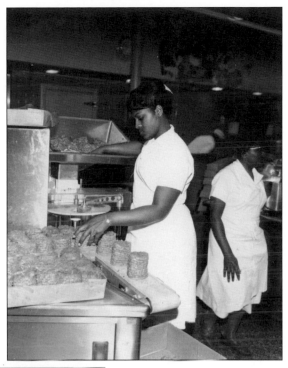

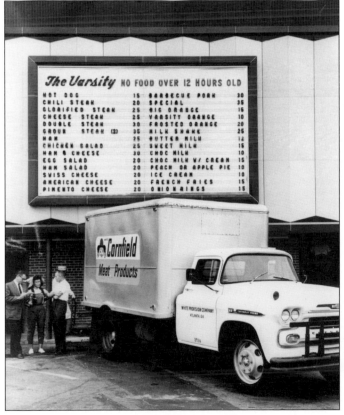

Trade magazines also stated that Atlantans ate 8,000 hot dogs daily. By the 1970s, that number reached almost 25,000. *Atlanta Magazine* quoted Gordy as saying, "Profits in Athens can't buy the meat used in Atlanta." The chili recipe was also Gordy's own personal concoction, using the best beef available and chili powder. By 1990, The Varsity was selling 300 gallons of chili daily. Standing next to the Cornfield truck here are Clyde Stinson (left), Connie Cornfield (Charlene Prow), and Ed Minix (right).

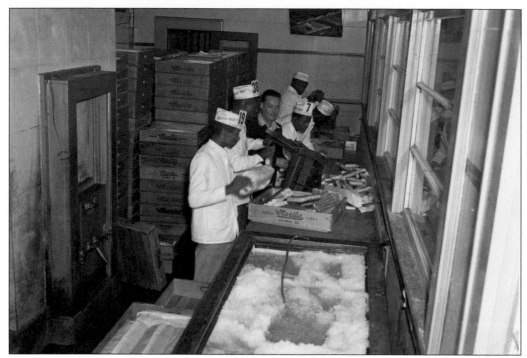

Carhop chief James Roach is shown supervising some of the curb boys as they slice hot dog buns. Gordy considered the bun almost as important as the dog itself. He insisted that the dog be able to sit in the bun from the top, unlike store-bought buns, which loaded the dogs from the side. For years, the buns were delivered whole and sliced in-house. (GSUL.)

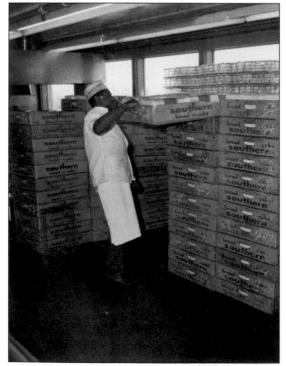

Like everything else, the bread for The Varsity is made specifically for the drive-in. The buns are steamed before the hot dogs or steaks are put on them, so they need to be able to hold up to the steaming process without falling apart. For this reason, buns for The Varsity are usually baked the day before they are used.

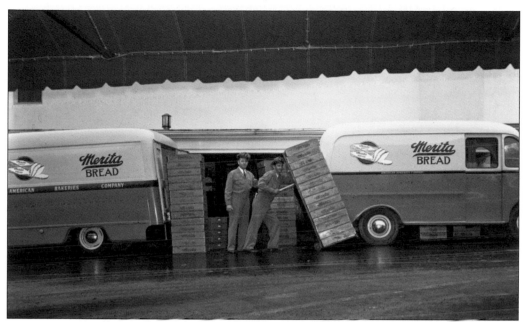

Having The Varsity as a customer was so important to Merita Bread that they featured the drive-in as a 1950 cover story for their company-wide magazine. This photograph shows Merita sales supervisor Lee Fouché (left) and salesman G.C. Bidgood making a delivery. Merita made two bread deliveries daily. By then, The Varsity had been the largest individual consumer of bakery products in the world for two decades. (GSUL.)

While hot dogs and hamburgers are the staple, a wide variety of sandwiches have always been on the menu, too. This 1980s-era photograph shows Clifton "Booty" Thompson working at the sandwich board. At the time, Booty was the oldest employee of The Varsity. A 1955 article about The Varsity pointed out that the sandwich-making counter was waist-high so that it was "more convenient and less tiring for countermen."

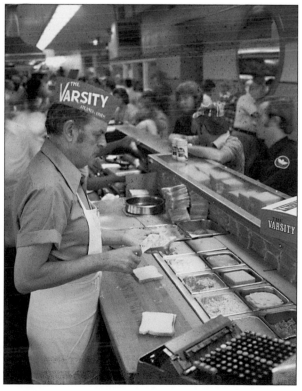

Even in the pre-Varsity days of the Yellow Jacket, Gordy sold Coca-Cola. He bragged that his iced Coke was chilled to 33 degrees. Coca-Cola World Headquarters was and is just blocks away from the North Avenue Varsity location. For decades, Gordy resisted selling Coke as a fountain drink, instead serving it in bottles; by 1963, The Varsity was going through 1,000 cases of Coke a week, requiring two deliveries a day.

Gordy said he did not want the Coca-Cola delivery driver to lose his job, so when the man retired in 1963, the switch was made to fountain drinks. The Coca-Cola Company's trade magazine, *The Refresher*, reported, "Coke sold at The Varsity restaurants is dispensed from satellite equipment and Figal tanks with six dispensers, each with three drafts . . . in constant use." By 2000, The Varsity was using 4,500 gallons of Coke syrup a week. (CC.)

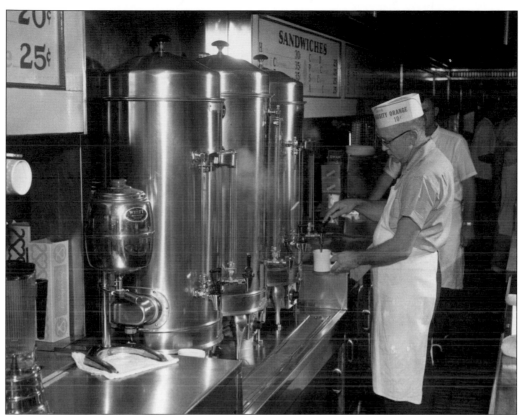

From the 1930s through the 1980s, The Varsity opened its doors at 7:00 a.m. each morning. In those days, there were not a lot of breakfast places nearby. While Gordy admitted he usually did not sell any hot dogs until after 9:00 a.m., the early hour was not about making money, but making friends. Above, day manager Johnny Hutchinson pours a cup of coffee from one of the massive urns behind the counter.

The image at right was taken for a series of 1960s advertisements for The Varsity. The unidentified carhop's trays are filled with the main items of The Varsity's menu. The tray on the left includes fries, hamburgers, and a peach pie, with a Coke and a Frosted Orange. On the right are two chili dogs, onion rings, a fried peach pie, a Varsity Orange, and a milk shake.

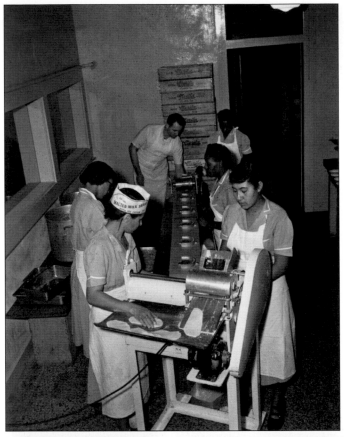

Fried pies were added to The Varsity's menu with the opening of the North Avenue location. Originally, they were made off-site by a baker and his wife at their home. When the demand grew, the baker came to work at The Varsity full time. Eventually, even he could not keep up, and Gordy designed a machine that would speed up the process. Those same machines are still in use. The dough is mixed, run through a press, and then put into molds that run along a conveyor belt. Filling is added along the way. The pies are folded, pressed, and then refrigerated until needed. With a six-person team, 2,400 pies can be made in an hour and the process is repeated twice daily. (Left, GSUL.)

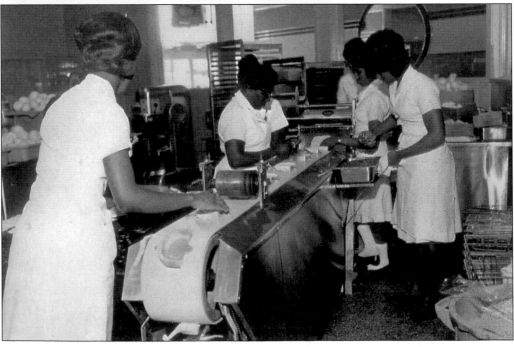

Each pie has an ice cream scoop of filling inside. As with every Varsity item, the apple and peach fillings are made fresh. Because the filling has to cool, the gallons of filling needed is cooked the day before. On days of football games when The Varsity triples its normal number of customers, extra filling is prepared starting at 7:30 a.m. Assembled pies are refrigerated and cooked as ordered.

The pies are fried in 350-degree oil for 7 to 10 minutes. The large wire racks they are loaded on can fit 20 to 25 at a time. Here, Erby Walker's sister-in-law Bessie Mae Walker is seen loading an uncooked rack into the fryer. The pies to her left are already cooked.

More than a ton of onions are sliced and diced daily at The Varsity. Workers used to have to peel the onions, too, but now they arrive without their skins. The outer rings are used for onion rings while the smaller ones are diced for use on hot dogs and in chili. Originally, onion rings were cooked in lard instead of canola oil.

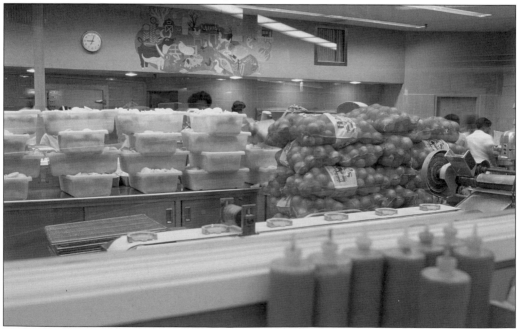

A glass window is all that separated customers from the aroma of the bags and bags of onions peeled and sliced daily. Gordy's mantra was "no food over 12 hours old," meaning most food was cooked and sold within 12 hours of its delivery. As if the taste were not proof enough, most food preparation took place behind glass windows so customers could watch and marvel.

French fry lovers know that when they step up to order at The Varsity they should order "strings," which is Varsity lingo for fries. While onions and other produce were procured from whatever area of the world had them in season, Gordy insisted on using only Idaho potatoes and could taste the difference if another spud was substituted.

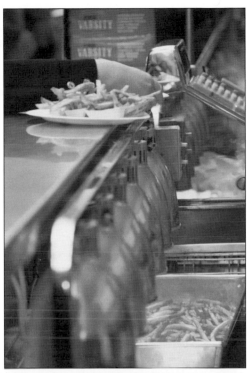

Potatoes were something Gordy agreed to store, since he felt that fresh potatoes were not good for frying. Therefore, several thousand boxes or bags of spuds were always kept on hand. The potatoes were and still are hand-cut daily. Eventually, the numbers of potatoes used reached the staggering volume of almost two tons per day.

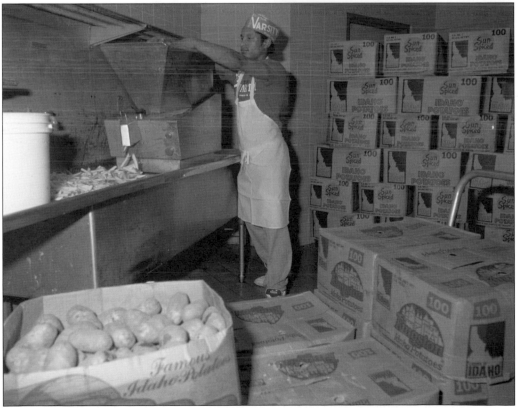

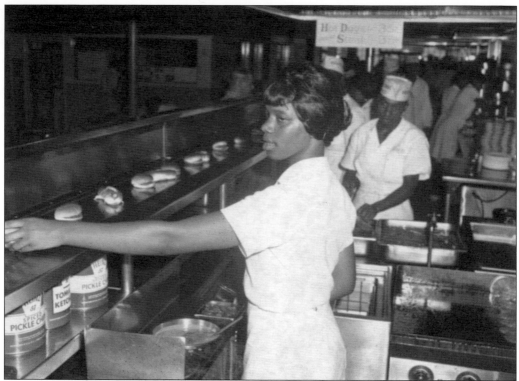

To keep the kitchen and serving areas running as efficiently as possible, Frank Gordy designed them to function like a factory assembly line. There were three behind-the-scenes assembly stations. Hot items then moved along a conveyor belt that stretched behind the 68-foot-long counter. Gordy got the idea after spending his teenage summers packing peaches at a farm that used a conveyor belt.

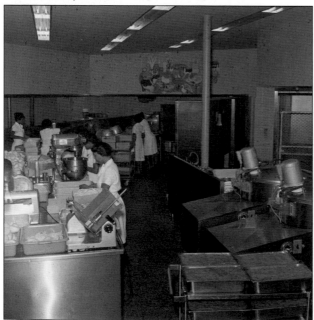

This 1963 photograph shows the various production areas of The Varsity kitchen. To the left are the stacks of onion rings, while the huge mixer in front of the women on the left was used for the chili. Those massive pots are still used to cook more than 300 gallons of chili daily. The motors on top of the covered bins on the right help mix 200 gallons of Orange drink each day. The pans in the foreground contain pie filling. (GSUL.)

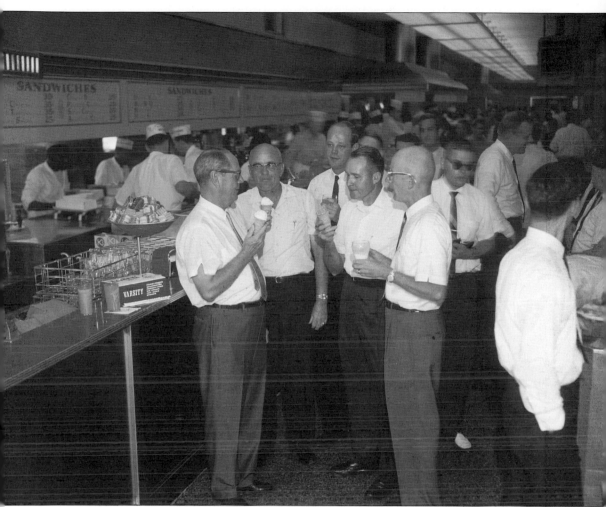

Frank Gordy loved ice cream and insisted that The Varsity's ice cream have a 17 percent butterfat content because he felt it tasted better than what was offered elsewhere. The ice cream was churned in-house at the North Avenue location until 1930, when Jersey Ice Cream Company's Fred Scanling convinced Gordy that his operation could make it more efficiently. Jersey Ice Cream was, at that time, located less than three miles away on Highland Avenue. With Scanling's assurances of quality, Gordy not only agreed to the proposition, he transferred his own equipment over to Jersey to help the process. Pictured here from left to right are Frank Gordy Sr., F.W. (Bill) Scanling, Frank Gordy Jr., Varsity manger Ed Minix, and E.L. (Roy) Scanling. Jersey is now a division of Greenwood Ice Cream.

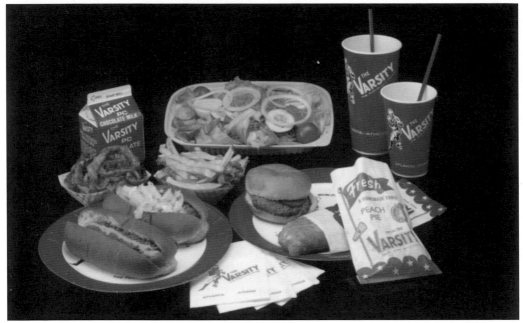

In the late 1980s, under the guidance of Nancy Gordy Simms, The Varsity made a move to expand the menu, adding items designed to appeal to those who were a bit more health-conscious, including a salad and a grilled chicken sandwich.

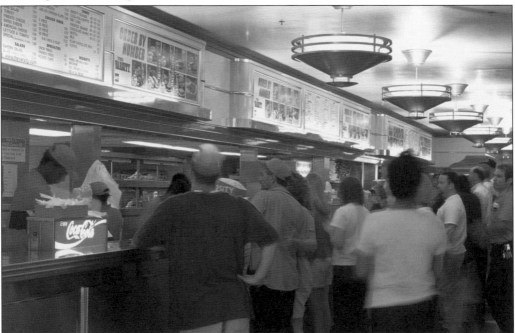

This picture was taken inside The Varsity during the 1996 Summer Olympics in Atlanta. The signs behind the counter show a new series of combination offerings. These combos were created in anticipation of accommodating the Olympic crowds. The Varsity's North Avenue location was directly across from the Olympic Village and was a favorite stop for athletes and Olympic visitors.

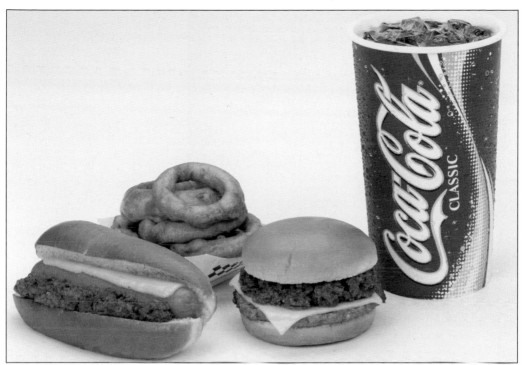

The combinations remain a popular option at The Varsity. This photograph, from a 2004 advertising campaign, includes the traditional chili dog with cheese, chili cheeseburger, onion rings, and a Coke, or for those fluent in the language of The Varsity, a hot dog, a chili cheese steak, ring one, and a Coke.

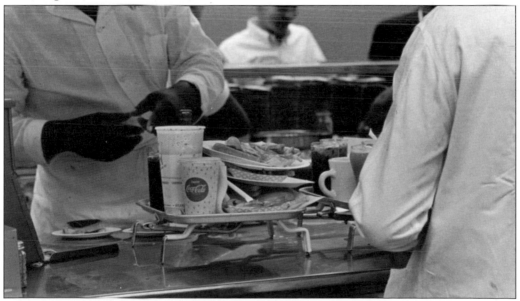

When the counterman hollers, "What'll ya have?," this photograph from the 1960s pretty much says it all. Headed to some lucky soul's car window, this tray contains dogs walkin', strings, a chili steak, sideways, a Varsity Orange, a Joe-ree and, of course, a Coke. To make sense of that order, turn to the next page. (CC.)

Varsity Lingo

What'll ya' have...What'll ya' have... is the constant chorus one hears above the crowd noise when you walk into the Varsity. Here is a list of the lingo so you know they got your order right.

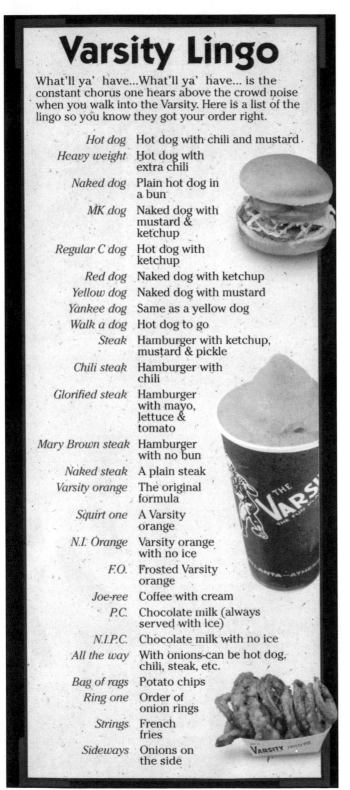

Hot dog	Hot dog with chili and mustard
Heavy weight	Hot dog with extra chili
Naked dog	Plain hot dog in a bun
MK dog	Naked dog with mustard & ketchup
Regular C dog	Hot dog with ketchup
Red dog	Naked dog with ketchup
Yellow dog	Naked dog with mustard
Yankee dog	Same as a yellow dog
Walk a dog	Hot dog to go
Steak	Hamburger with ketchup, mustard & pickle
Chili steak	Hamburger with chili
Glorified steak	Hamburger with mayo, lettuce & tomato
Mary Brown steak	Hamburger with no bun
Naked steak	A plain steak
Varsity orange	The original formula
Squirt one	A Varsity orange
N.I. Orange	Varsity orange with no ice
F.O.	Frosted Varsity orange
Joe-ree	Coffee with cream
P.C.	Chocolate milk (always served with ice)
N.I.P.C.	Chocolate milk with no ice
All the way	With onions-can be hot dog, chili, steak, etc.
Bag of rags	Potato chips
Ring one	Order of onion rings
Strings	French fries
Sideways	Onions on the side

Curb men invented The Varsity lingo sometime around the 1930s. When the counterman calls "What'll ya have?," "have your order on your mind." This back page of a 1990s brochure helps guide the uninitiated as to what the order taker's shorthand really means. Knowing it all by heart is not a requirement, although it does help to know some of it. If a customer orders a hot dog to go, they will be sure to hear, "Walk me a dog." The origin of much of the lingo seems obvious, but others are a bit of a mystery. From the beginning, however, Frank Gordy preferred calling hamburgers "steaks" because it sounded better. The late carhop known as Flossie Mae would sing the entire menu to his customers.

Five

THE VARSITY FOREVER

Nancy Gordy Simms began training to run The Varsity in the early 1980s under the watchful eye of longtime manager Ed Minix. She said her biggest regret is that she was never able to work alongside her father, but she got plenty of guidance from Minix and her mother, Evelyn Gordy. Evelyn served as chairman of the board of The Varsity, while Nancy was president.

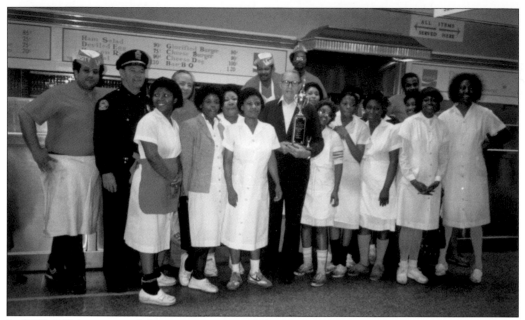

In 1985, Ed Minix retired, leaving operation of The Varsity to Nancy Gordy Simms. He is shown here at his farewell with several employees. While not everyone is identified, longtime employees Rebecca Deblah and Jaida Danso are next to Minix on the left, while Dee Dee Zepha Chambliss and Betty Thomas stand immediately next to him on the right. Erby Walker is over Minix's right shoulder.

On April 23, 1985, Coca-Cola chose The Varsity as the kickoff site for the launch of New Coke. Coca-Cola president Don Keough worked behind the counter with Nancy Gordy Simms to serve up samples of the soft drink, which was designed to replace the original Coke. The launch was a success, but the product itself was a failure. In a blind taste test, 62.5 percent of Varsity customers preferred the original Coke.

Automatic teller machines, or ATMs, were still rather new even at banks when The Varsity got its own machine on November 18, 1988. Pete McEvoy, the manager of the First National Bank of Atlanta's North Avenue Banking Center, joined Nancy Gordy Simms in inaugurating the bank's first "Tillie" to be put in a restaurant. The Varsity Tillie was First Atlanta's 95th in metropolitan Atlanta and the 142nd in Georgia.

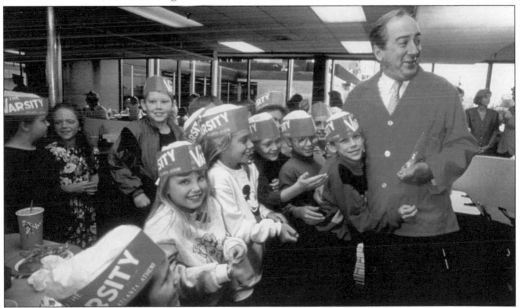

With the Coca-Cola World Headquarters just a few blocks up the street from The Varsity, the company chairman, director, and chief executive officer Roberto Goizueta was a regular. On the day this picture was taken, a teacher visiting the drive-in with her students recognized Goizueta and sent them over to him to sing the "Always Coca-Cola" jingle. (CC.)

The Democratic National Convention took place in Atlanta in the summer of 1988 and The Varsity was chosen as the location for a meeting with the vice chairs of the Democratic National Committee. Sponsored by the securities firm Cranston/Prescott, it was attended by politicians and a host of celebrities as well as voters.

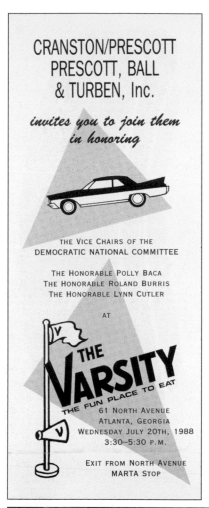

CRANSTON/PRESCOTT
PRESCOTT, BALL
& TURBEN, Inc.

*invites you to join them
in honoring*

THE VICE CHAIRS OF THE
DEMOCRATIC NATIONAL COMMITTEE

THE HONORABLE POLLY BACA
THE HONORABLE ROLAND BURRIS
THE HONORABLE LYNN CUTLER

AT

THE VARSITY
THE FUN PLACE TO EAT

61 NORTH AVENUE
ATLANTA, GEORGIA
WEDNESDAY JULY 20TH, 1988
3:30–5:30 P.M.

EXIT FROM NORTH AVENUE
MARTA STOP

The Varsity was packed. Among those present were, from left to right, celebrities Edward Asner, unidentified, Linda Lavin, and Ed Begley Jr. Others in attendance included Mike Farrell, Margot Kidder, and Richard Masur, plus members of the Democratic National Committee and state and local elected officials.

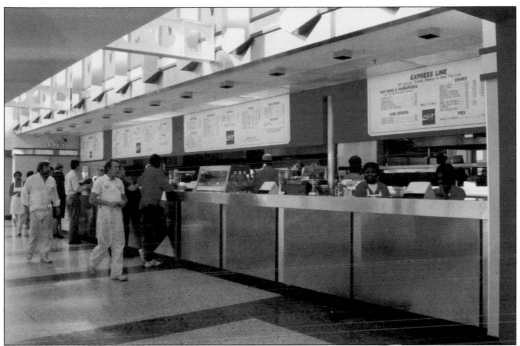

In 1990, the first new Varsity in more than 20 years opened its doors in Gwinnett County with a third-generation Gordy at the helm. Nancy Gordy Simms's son Gordon Muir had grown up shadowing his grandfather at the downtown store and had his first real job working the grill at The Varsity Jr. When the 10,000-square-foot location opened off Interstate 85, Muir was the manager.

John "Flossie Mae" Raiford worked at The Varsity until 1993, when he retired at age 86. He worked as the No. 4 carhop for 56 years. At his retirement party, he sported one of his infamous self-decorated hats festooned with fans, flowers, and even a teddy bear in a swing. Flossie periodically made appearances at The Varsity until his death in 1997. (AWT.)

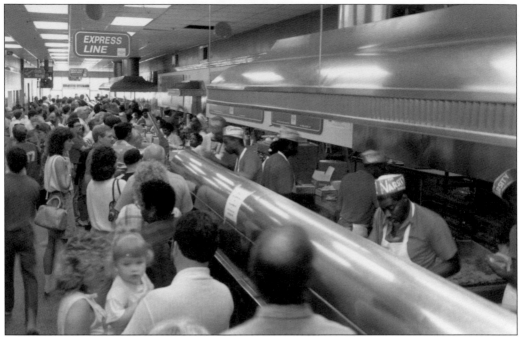

This packed house may look like a typical day at The Varsity, but guests were here to help celebrate the drive-in's 60th anniversary in 1988. In the back of the image, at far left, one can see a Varsity Gift Shop sign. The gift shop opened as part of the celebration, selling hats, T-shirts, cups, buttons, and bumper stickers.

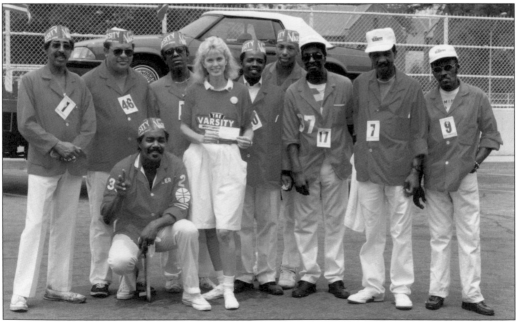

The 60th anniversary celebration included a raffle for a red Mustang convertible. Here, Nancy Gordy Simms stands in front of the Mustang with a group of carhops. Pictured from left to right are Frank Jones, Will Presley, Joseph, Nancy Gordy Simms, Stanley Fluker, Michael Jones, Oscar Jones, Curt Jackson, and Chuck. Kneeling is Dexter Willis.

Georgia Tech's official mascot, the Ramblin' Wreck, was one of the cars included in the car show at the 60th anniversary celebration. The 1930 Ford Model A Sport coupe had an even more special meaning to Evelyn Gordy-Rankin because, she said, it was similar to the car she and her husband, Frank, drove on their honeymoon.

A joyous Evelyn Gordy-Rankin is shown here signing an anniversary poster next to her longtime friend Peggy Fletcher. The giveaway posters commemorating the event were wildly popular, sparking a rush from Varsity fans hoping to score a copy. Members of the Gordy family found themselves treated like celebrities by those who sought to have their posters signed.

The Varsity has only undergone four major renovations, and the last was in 1993 in anticipation of the 1996 Summer Olympics. The kitchen had not had a major overhaul since the 1940s, so work got underway to update equipment and prepare for massive crowds. For the first time, customers were not able to view the kitchen to watch all the preparations.

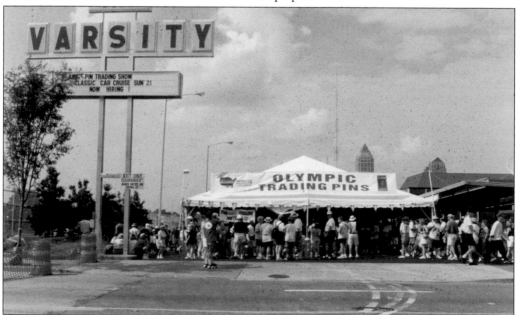

Pin trading is an Olympic tradition. Nancy Gordy Simms had attended the 1994 Winter Olympics in Lillehammer, Norway, and was among those who caught pin-trading fever. She knew The Varsity had to be involved. While Coca-Cola was committed to having their official pin-trading area in Centennial Park, Nancy helped create a 10,000-square-foot tented Olympic pin-trading center at The Varsity.

The Varsity created its own pin series to trade during the Games. Those shown above are some that did not make the cut. The one on the right paid tribute to The Varsity's location. The Olympic Village, which housed the athletes, was located just across Interstate 75/85, and one of the entrances was on North Avenue, just a block from The Varsity.

Of the pins that were created for The Varsity, one in particular created quite a furor. It showed a "walkin' box" of onion rings, but the International Olympic Committee thought the rings looked too much like their trademarked Olympic rings. Claiming an unauthorized use of the Olympic symbol, they stopped the sale of the onion ring pins, confiscating those on hand at The Varsity.

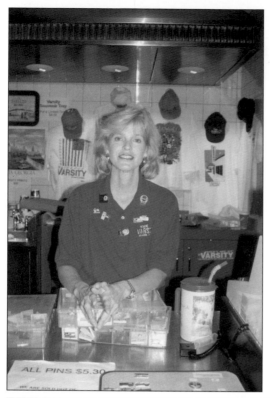

Before the onion ring pins were confiscated, a few had already been sold and they were among the most coveted pins of the Atlanta Games. Nancy Gordy Simms had her own stash of the pins and says someone actually traded her an emerald in return for one of the forbidden onion ring pins.

Varsity manager Erby Walker was chosen to carry the torch on a leg of the Olympic Torch Relay prior to the Games. He would later say that it was his proudest moment. After his run, he brought his torch back to The Varsity so that his coworkers could all share in the moment. Pictured here from left to right are Rebecca Dablah, Monica Sherten, Dee Dee Zepha Chambliss, Erby Walker, and Jaida Danso. (AWT.)

Throughout the Games, The Varsity's location on North Avenue near the Olympic Village made it a favorite stopping place for visitors from throughout the world. NBC's *The Today Show* featured the World's Largest Drive-In, as well as the pin-trading area. *Today Show* host Katie Couric is shown here interviewing Nancy Gordy Simms. Couric even donned an apron and worked the counter.

The 12-story tower with a 16-foot flame on top of it, located in The Varsity's north parking lot, was the creation of former Georgia Tech football player Taz Anderson. Called the Centennial Tower in honor of the 1996 Olympics, Anderson envisioned the tower as a tourist destination. Visitors can climb to the 100-foot-high observation deck for a view of Atlanta.

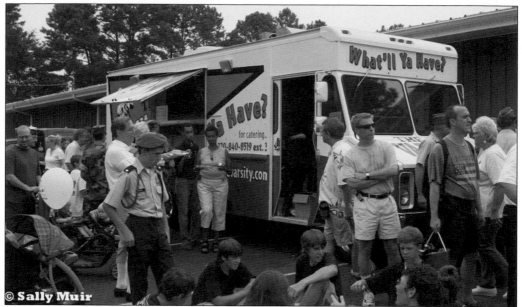

The Varsity received so many requests for large outside orders that in the 1990s, they began a full-scale catering operation. For years, Gordon Muir operated the service out of the Gwinnett location where he was manager. To maintain the quality of the food with such large requests, the idea was developed to create a catering truck with a complete kitchen inside. This way, just as in the restaurant, food would be cooked only as needed, following founder Frank Gordy's promise that all food from The Varsity is as fresh as possible. By 2011, The Varsity had six fully operation catering trucks that handle everything from small birthday parties to large corporate events. The photograph below shows Varsity trucks making their preparations for Delta Airlines' Employee Appreciation Day—an annual catering event. During the 1996 Atlanta Olympic Games, The Varsity catered a 27,000-person event for Delta. (Above, Sally Muir.)

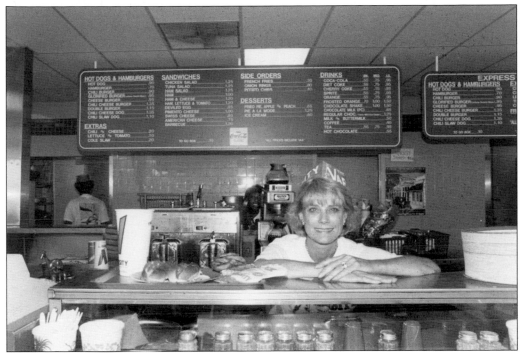

Susan Gordy is shown behind the counter of The Varsity Jr., which she took over after her husband's death in 1980. Her background had been in fashion merchandising, but when she assumed control, she learned the ropes quickly and made the business her life. She worked there until retiring in 2006, when she sold the franchise back to The Varsity.

This photograph is a testament to the popularity of The Varsity's catering. Chick-fil-A founder Truett Cathy says he got many ideas about how to run his business from his friend Frank Gordy. He is shown here with Gordy's widow, Evelyn Gordy-Rankin, at his 80th birthday celebration. The party was catered—not by Chick-fil-A, but by The Varsity—and Cathy is a frequent diner at The Varsity.

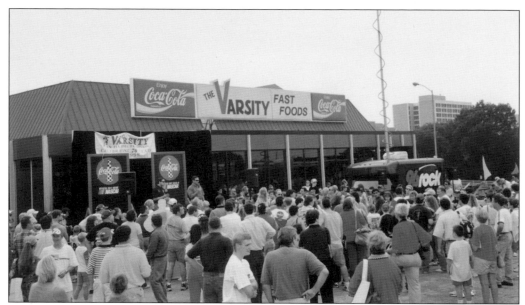

When NASCAR and Coke team up for a national tour, The Varsity is a virtual "must" when it comes to stops on the tour. In 1998, Tony Stewart and Bobby Labonte were on hand on the Lunching Pad to greet thousands of fans. That year, Labonte had won NASCAR's race at the Atlanta Motor Speedway. The year 1998 was Stewart's first full year racing NASCAR.

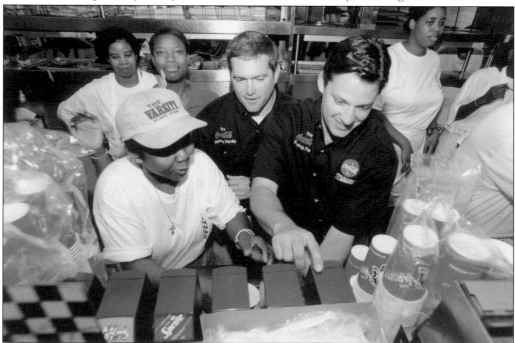

Racing cars may be their specialty, but serving drinks at The Varsity required a little instruction as NASCAR drivers Bobby Labonte and Tony Stewart tried their hands behind the counter. They are shown here getting tips on their service techniques from veteran counterperson Rebecca Dablah. From left to right are Leta Abraha, Rebecca Dablah, Cynthia Jewel, Bobby Labonte, and Tony Stewart.

While Nancy Gordy Simms says she rarely paid visits to her father at The Varsity when she was growing up, the same cannot be said for her children and grandchildren. From left to right are daughter-in-law Sally Muir; grandson Matthew Muir; granddaughters Elizabeth, Charlotte, and Ashley Muir; Nancy Gordy Simms; and Joseph Muir. Paul Muir is in the stroller.

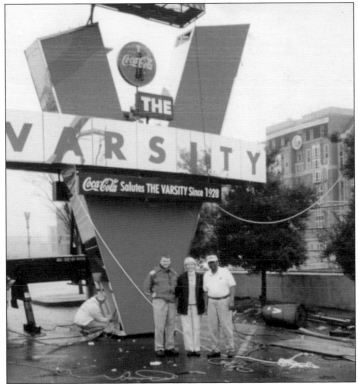

On December 18, 2000, a new, high-tech sign in the shape of "V" was erected outside The Varsity. Visible from the Interstate 75/85 connector, the 45-foot-tall sign was created in partnership with Coca-Cola. "Coca-Cola Salutes The Varsity Since 1928" crosses the center. On the same day the sign was dedicated, The Varsity launched their website, thevarsity.com. Here, director of operations Terry Brookshire (left) poses with Nancy Gordy Simms and Erby Walker.

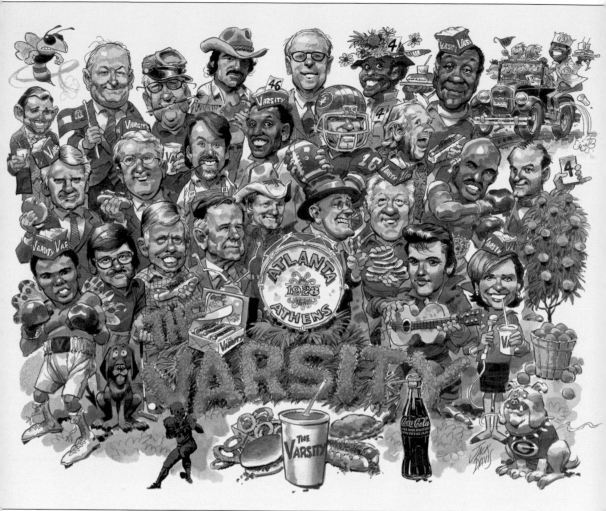

This illustration by noted cartoonist Jack Davis shows only some of the celebrities who have dined at The Varsity or on Varsity food. They are, from left to right, as follows: (first row) Muhammad Ali, Lewis Grizzard, Jimmy Carter, George H.W. Bush, Jerry Reed, Franklin D. Roosevelt, Bill Clinton, Elvis Presley, and Katie Couric; (second row) Zell Miller, former Georgia governor Roy Barnes, Jeff Foxworthy, Nipsey Russell, Joe Montana, Jimmy Buffett, Evander Holyfield, and Bob Hope; (third row) Georgia Tech's mascot, Buzzy, hovering over Clark Gable; former Georgia governor Sonny Perdue; Jack Davis; Burt Reynolds; Frank Gordy; carhop Flossie Mae (John Raiford); and Bill Cosby. Jack Davis was one of the founding cartoonists at *Mad Magazine*.

This note from Lucie Arnaz to Frank Gordy was among the autographs of celebrity customers that The Varsity's founder kept pasted on the glass window above his desk. He used her "Wow! What an experience!" line on the cover of the 1978 Varsity brochure. While Elvis Presley never ate at The Varsity in person (to the staff's knowledge), he did send for hot dogs when he was in town.

Several Varsity staff members have become celebrities themselves over the years. Carhop Frank Jones is seen here talking an order from the Travel Channel's Samantha Brown. The drive-in was featured in her show *Great Weekends*. The Varsity is considered one of the top eating destinations in Atlanta.

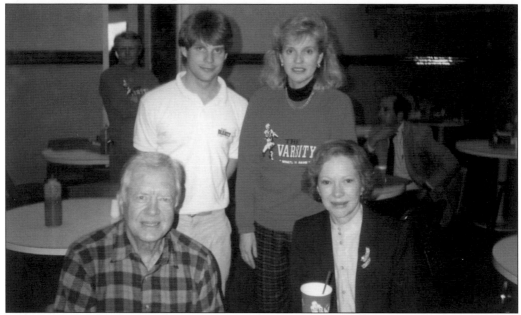

Pres. Jimmy Carter and his wife, Rosalynn, could be called Varsity regulars. The former president admits to visiting countless times over the years, dating back to before his days as Georgia's governor. Pictured here with Gordon Muir and Nancy Gordy Simms, the Carters stopped by while in Atlanta to do business at the Carter Center.

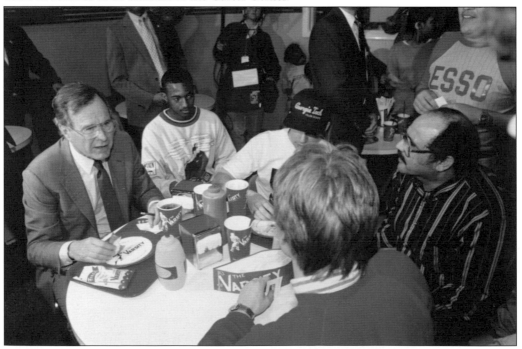

Pres. George H.W. Bush came to The Varsity in 1990 and stayed long enough to enjoy a hot dog, peach pie, and a Coke. After ordering, he and Varsity vice president Gordon Muir (with back to camera) headed to the dining room, where the president chose to sit with some customers who were already eating. General manager Joe Shalabi is to the right of Muir.

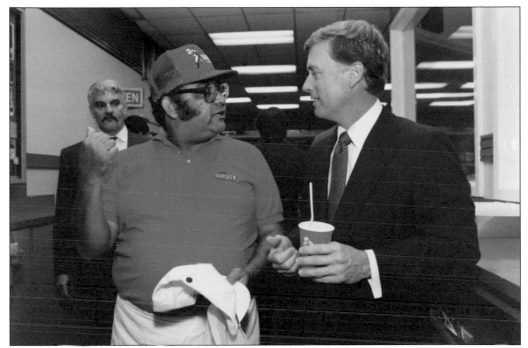

George H.W. Bush's vice president, Dan Quayle, paid his own visit to The Varsity just a few months later. Quayle ordered a Frosted Orange and was greeted by general manager Joe Shalabi. Born in Bahrain, Shalabi was attending Georgia Tech in 1973 when he began working part-time dipping ice cream. Ed Minix later hired him full-time as a cashier, and he was promoted to general manager in 1983.

Former Georgia governor Zell Miller introduced former president Bill Clinton to The Varsity. Known for his love of hot dogs and burgers, the president went the hamburger route during his visit, but also partook of onion rings and a Coke. Miller grew up three blocks from The Varsity and shared stories of how he used to skip school to hang out at the drive-in.

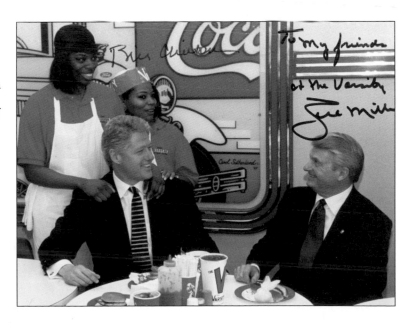

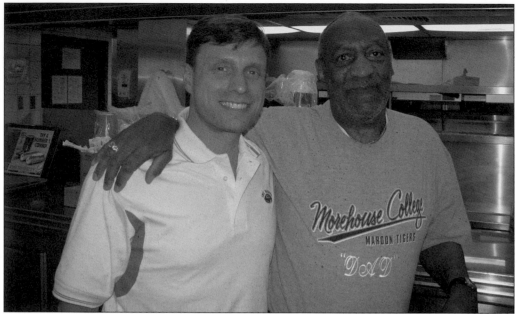

Bill Cosby considers himself a Varsity aficionado and tries to visit whenever he is in town, which has been often. In addition to traveling to Atlanta for performances, Cosby came to visit his daughters, who attended Spelman College. Cosby is also a strong supporter of Atlanta's Morehouse College. Here, Cosby is pictured with director of operations Terry Brookshire. Brookshire joined The Varsity in April 1998.

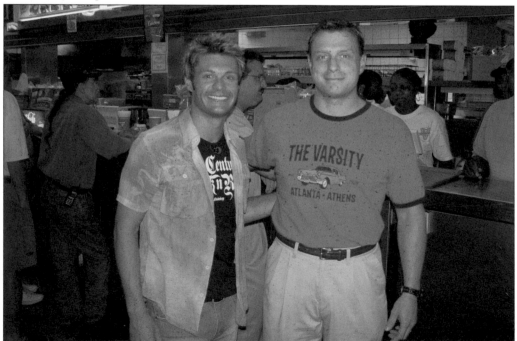

American Idol host Ryan Seacrest is all too familiar with The Varsity, having grown up in the Atlanta suburb of Sandy Springs. In fact, Seacrest got his start in show business by working on the radio in Atlanta. Seacrest is shown here with Terry Brookshire.

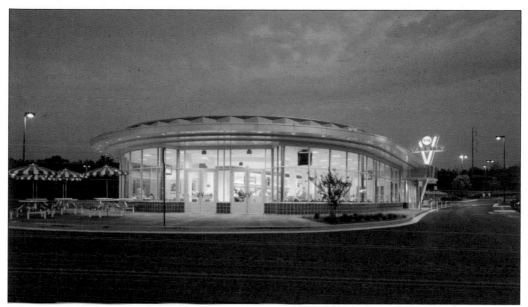

After the success of The Varsity location in Gwinnett, The Varsity started looking for a location in Cobb County. The Varsity Town Center opened its gleaming Art Deco doors behind the Town Center mall in the summer of 1999. This 12,000-square-foot restaurant duplicated some of the charm of the original Varsity, complete with televisions in the dining areas and halls lined with historic Varsity photographs.

When The Varsity opened its fifth restaurant in August 2003 in the town of Alpharetta, just north of Atlanta, the occasion was a family affair. Pictured here are, from left to right, John Browne, Carrie Muir Browne, Stephen Simms, Nancy Gordy Simms, Evelyn Gordy-Rankin, Gordon Muir, and Sally Muir.

After working at The Varsity for 50 years, Erby Walker (right) retired in December 2001. Although he proclaimed, "This is the day I worked so hard for," retirement did not stick. He returned a few months later, working until his death in 2008. With Walker is Frank Jones, who started as a carhop in 1948. As of 2011, Jones still worked at The Varsity. (AWT.)

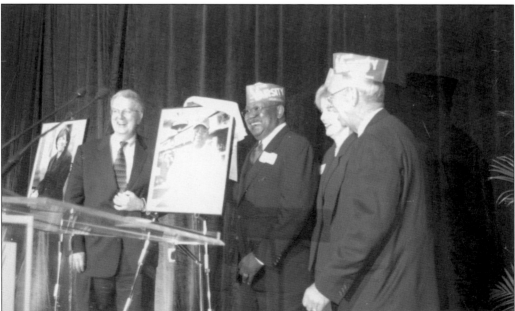

On October 9, 2003, Erby Walker was inducted into the Georgia Convention and Visitors Bureau's Hospitality Hall of Fame. The honor was bestowed by Gov. Roy Barnes. Pictured from left to right are Governor Barnes, Walker, Nancy Gordy Simms, and an unidentified representative of the GCVB. Other inductees that year included former Atlanta mayor Maynard Jackson, who had recently passed away, and Marge McDonald, founder of Tour Gals. (AWT.)

Erby Walker raised 12 children on his Varsity salary and a number of them were at the Georgia Convention and Visitors Bureau's Hospitality Hall of Fame to help him celebrate. Shown here with Erby Walker are, from left to right, his daughters Tangia Walker and Rhonda Walker, daughter-in-law Erica Walker, daughter Anissa Walker Thompson, son Shawn Walker, Erby, friend Ann Rozier, son Derry Walker, daughter Yasmin Walker, and son Erby Walker Jr. (AWT.)

In 2005, the movie *We Are Marshall*, starring Matthew McConaughey, was shot in Atlanta and The Varsity was the perfect location to depict scenes from the 1970s. McConaughey is shown here among some of the production staff in the bridge dining area. The movie dealt with the aftermath of a 1970 plane crash that killed 37 Marshall University football players.

In 2008, on The Varsity's 80th anniversary, the drive-in once again threw itself a birthday party. In addition to a vintage car show, there were bands and cake with ice cream, courtesy of Mayfield Dairy. The Varsity family and staff members gathered here are, from left to right, Gordon Muir, Steve Simms Jr., Steve Simms Sr., Nancy Gordy Simms, Carrie Muir Browne, John Browne, Livvie Brookshire, Julie Brookshire, Zachery Brookshire, and Terry Brookshire.

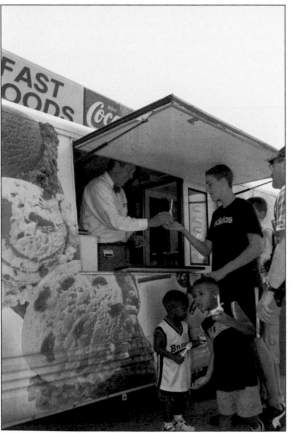

Scottie Mayfield, president of Mayfield Dairy, turned out for the celebration to help scoop ice cream from the Mayfield truck. Mayfield knows a little bit about staying power himself—Mayfield, one of the nation's leading dairies, was founded by Scottie's great-grandfather in 1910 and celebrated its 100th anniversary in 2010, two years after The Varsity's 80th.

During the 80th anniversary celebration, Nancy Gordy Simms shares a moment with Joe Patten, the man credited with saving the Fox Theatre from destruction in the 1970s. Patten also helped restore, by hand, the Fox's legendary pipe organ, known as "Mighty Mo." A vintage car collector, Patten brought his 1937 Rolls-Royce Sedanca de Ville to show off at the anniversary car show.

As it has been from the beginning, staff members of The Varsity become family and many stay for decades. This group photograph represents over 100 years of service. Pictured here from left to right are Mary Sherton, Patricia Jones, Janet Anoche, Nicole Stephens, Olivia Varela (in front of Nicole), Elton Drayton, Angela Smith, Dee Dee Zepha Chambliss (with her arm raised), Gloria Anderson, Valerie Jackson, Dede Akue, Lete Welela, Jaida Danso, and Mary Seda.

Buses for the Metro Atlanta Rapid Transit Authority, or MARTA, found themselves wrapped in Varsity red in a new advertising campaign for the drive-in. At the North Avenue MARTA rail station in 2007, it was hard for riders to avoid the fact that this particular stop would take them to The Varsity. It was festooned with images of Varsity food decorating walls, columns, and even the floors. The copy written for the campaign instructed riders to exit the station and "Follow your nose." They made such proclamations that The Varsity was "Atlanta's Grand Central Station" and that "Chicago has the 'L,' We've got the 'V!'" Yet another poster challenged readers to "Take a bite out of an Atlanta landmark."

For decades, The Varsity was open on Christmas, but now it closes to allow the staff to spend time with their families. Because The Varsity counts staff as extended family, it hosts its own pre-Christmas holiday dinner. Valerie Jackson is shown here in a Santa hat on December 24, 2009, helping serve the feast. From left to right are Douglas Bibbs, his daughter Trina, Hamed Sanogo (in the apron next to the pole), and Valerie.

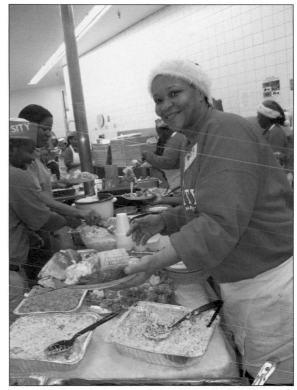

Carhops No. 22, Michael Daniel, and No. 11, Robert Thomas, came in from the parking lot to enjoy the holiday spread. The staff's families were also invited to take part in the celebration. The doors to the drive-in remained open during the dinner, so employees and customers dined on vastly different fare alongside one another in the dining rooms.

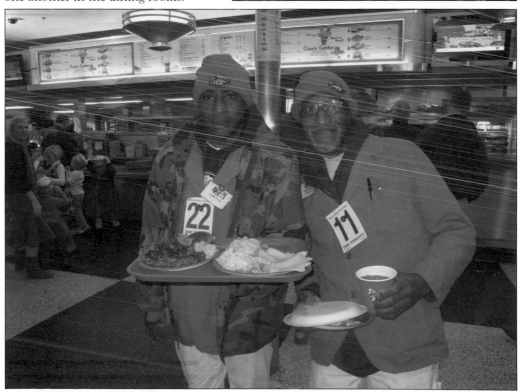

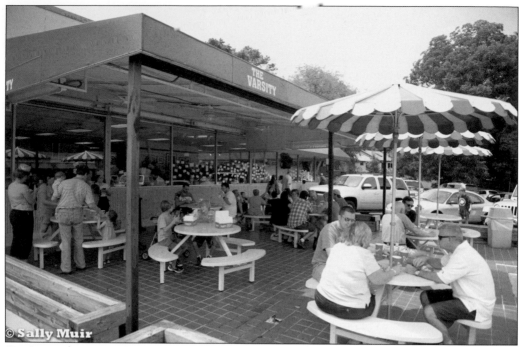

© Sally Muir

On August 22, 2010, after 45 years at the Lindbergh Drive location, The Varsity Jr. was forced to close its doors after being unable to meet the City of Atlanta's zoning requirements. The decision was a hard one, and loyalists turned out by the hundreds to have one last meal. The little squares on the glass of the front window are notes that customers started spontaneously posting.

By the end of the day, the glass was filled with messages from Varsity Jr. fans who offered up their memories and testimonials. Numerous notes implored The Varsity Jr., "Don't leave" or "Please stay!" But it was not to be. The Varsity Jr. closed its doors at 10:00 p.m. that night.

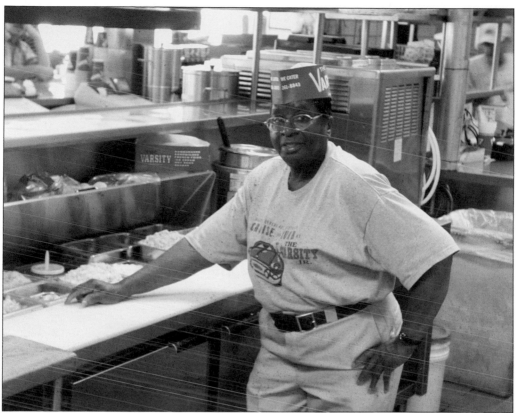

Less than three weeks before the closing of The Varsity Jr., they lost one of their longest and most beloved staff members. Annie Gresham started work at The Varsity in 1952, transferring to the Varsity Jr. after her husband died in 1978. At the time, the chili and batter were still coming from downtown. "Miss Annie" was quoted as saying, "I taught them how to make all of that right here."

In 2011, a new Varsity Jr. opened in Dawson County, north of Atlanta. Carrie Muir Browne was at the 4,550-square-foot restaurant for the festivities with her family. The new Varsity Jr. includes seating for 150 and a playground for children. From the left are Claire, John, Catherine, Carrie, and Caroline Browne.

© Sally Muir

In a case of history perhaps repeating itself, Gordon Muir's children could follow in the footsteps of their great-grandfather, their grandmother, and their father. They are no strangers to pitching in and helping out in the family business on special occasions. Ashley Muir is shown here working a summer job as head cashier at The Varsity Jr. (Sally Muir.)

Joseph Muir helps out behind the counter at the North Avenue Varsity. Joseph may have needed a little help to be able to see over the counter to serve customers, but that did not diminish his enthusiasm. Ashley and Joseph's great-grandfather, Frank Gordy, would no doubt be proud that The Varsity tradition lives on in a fourth generation.

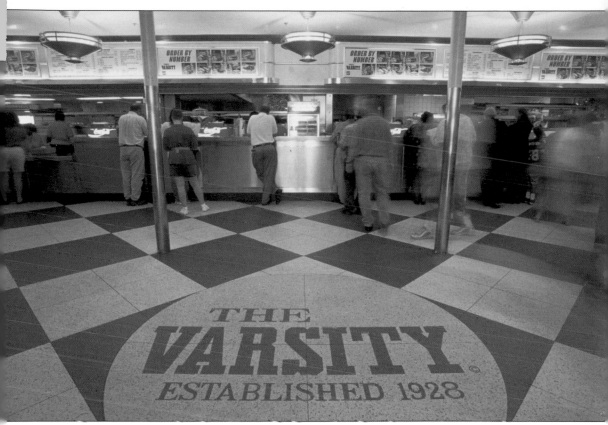

When Frank Gordy opened the doors of The Varsity in August 1928, he had a goal to bring quality food to customers at an affordable price. What he created was not just a restaurant, but also an institution. The Varsity has been an integral part of untold lives over the decades, creating countless memories over as many meals. When asked, "What'll ya have?," the lasting response should be, "The Varsity."

www.arcadiapublishing.com

MAP SEARCH

Discover books about the town where you grew up, the cities where your friends and families live, the town where your parents met, or even that retirement spot you've been dreaming about. Our Web site provides history lovers with exclusive deals, advanced notification about new titles, e-mail alerts of author events, and much more.

MADE IN THE

USA

Arcadia Publishing, the leading local history publisher in the United States, is committed to making history accessible and meaningful through publishing books that celebrate and preserve the heritage of America's people and places. Consistent with our mission to preserve history on a local level, this book was printed in South Carolina on American-made paper and manufactured entirely in the United States.

This book carries the accredited Forest Stewardship Council (FSC) label and is printed on 100 percent FSC-certified paper. Products carrying the FSC label are independently certified to assure consumers that they come from forests that are managed to meet the social, economic, and ecological needs of present and future generations.

FSC

Mixed Sources
Product group from well-managed
forests and other controlled sources

Cert no. SW-COC-001530
www.fsc.org
© 1996 Forest Stewardship Council

Find Your Place in History.